How To Draw

Tattoo STYLE

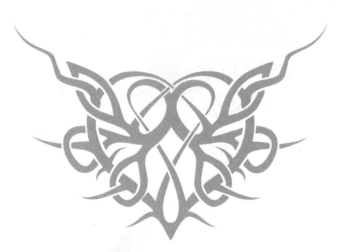

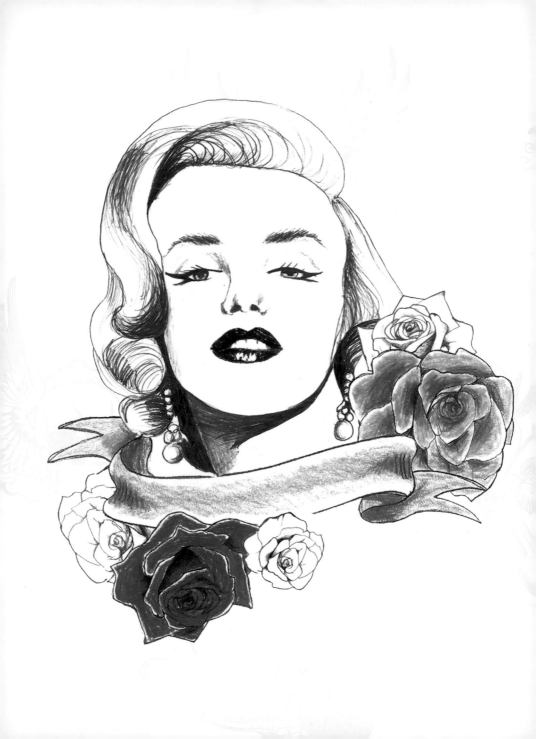

How To Draw

Tattoo STYLE

Andy Fish with Veronica Hebard

featuring projects by real tattoo artists

Search Press

This edition published in 2012 by
Search Press Ltd
Wellwood
North Farm Road
Tunbridge Wells
Kent TN2 3DR
www.searchpress.com

A Quintet book
Copyright © Quintet Publishing Limited
All rights reserved.
QTT.DYT

This book was conceived, designed and produced by
Quintet Publishing Limited, The Old Brewery, 6 Blundell Street,
London N7 9BH, UK

Project Editor: *Asha Savjani*
Designer: *Rehabdesign*
Art Editors: *Zoë White, Jane Laurie and Mat Deaves*
Art Director: *Michael Charles*
Managing Editor: *Donna Gregory*
Publisher: *James Tavendale*

Printed in China by Midas Printing
International Limited

Library of Congress Cataloging-in-Publication
Data available upon request

ISBN: 978-1-84448-835-3
10 9 8 7 6 5 4 3 2

Contents

Introduction

attoos have been in existence for as long as man has been drawing images. The desire to display permanent drawn markings on our bodies goes back to prehistoric times.

Tattoo

The word comes from the Tahitian *tatu* meaning 'to mark something'. Though an ancient practice, tattoo art is now one of the fastest-growing and most popular forms of art. These days 'tattoo parlours' tend to be more like high-end beauty salons than the stereotypical (and perhaps intimidating) places you might have thought of only a few years ago.

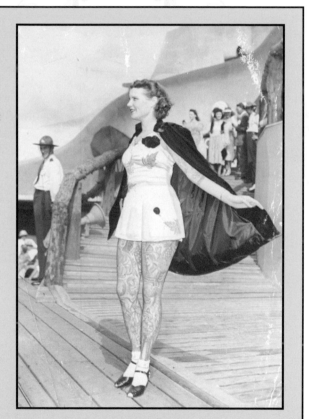

Vintage portrait of a tattooed woman.

Designing tattoo art is a challenging discipline – the artist is working with a two-dimensional design which will be applied to a three-dimensional object – the body. Ensuring that the design is visually appealing as well as practical involves a lot of skill. Many artists work as designers only and leave the actual placement of the tattoo on the body to another artist (these roles are sometimes differentiated as 'design artists' and 'skin artists'). This book explores the various opportunities you might have when you come to create your own tattoo designs.

There are many difficulties and challenges that are specific to this art form, and these are explored later in the book with help from several talented tattoo artists.

The roots of tattoo art

In recorded history, the earliest examples of tattoo art can be linked to Egypt during the time the pyramids were built (around 4,000 years ago).

However, tattoos have since been important in a range of cultures through the ages; the art of marking the human body has taken a varied path. People have used tattoos for a variety of reasons: to align themselves with a particular tribe or group, to demonstrate standing in a particular sect or even to indicate criminal activity.

The Greeks often tattooed spies, showing their allegiance and rank. The Romans used tattoos to lay claim to a slave or to identify someone who had been convicted of a crime. In Japan tattooing developed into a religious and ceremonial rite, and was later used to mark criminals. First offenders were marked by a line across the forehead, with a second offence adding an arch over this first one, while the third offence added yet another line, creating the Japanese character for 'dog' – thus criminals were labelled for life for all to see.

The attitude towards tattoos evolved, however, and the Japanese were among the first to introduce the idea of the full body tattoo. Since only royalty were allowed to dress ornately, more common folk adopted the practice of attaining the elaborate full-body style tattoo so that they could 'dress to impress', even if it meant being undressed in the privacy of their homes.

Western cultures such as the Norse often displayed their family crests as tattoos, and early Britons incorporated them into ceremonies. In CE 787, Pope Hadrian banned the practice and it virtually disappeared from Western culture from the twelfth to the sixteenth century.

A British sailor named William Dampier was responsible for bringing the idea of the tattoo back to Western culture in the late 1600s. Returning to London from the South Seas, he brought with him a heavily tattooed man who was known as 'The Painted Prince'. His appearance in an exhibition in London, while startling to many, was inspiring enough to re-ignite interest in the art. It would, however, take the similar visit of Captain Cook some 80 years later, bringing his own 'human canvas' back, heavily tattooed, from the South Seas and putting himself on display, to inspire the craze of getting a tattoo in other individuals.

Initially it was the upper classes who started to get small, discreet tattoos. This was due in no small measure to the slow and difficult process of creating the art using a single needle dipped in ink for each application. In 1891, with the advent of the first electric tattoo machine, the average person was able to get a tattoo, and at a reasonable price, which caused the upper classes to turn away from it.

By the turn of the nineteenth century, however, tattooing had lost its appeal. Circuses featured 'freak shows' with people tattooed from head to toe, and tattoo parlours themselves were often confined to the worst parts of town. However, tattooing has become increasingly popular in recent years because it presents anyone with the opportunity to own, wear and display a unique piece of customised art; each tattoo is an example of original artwork.

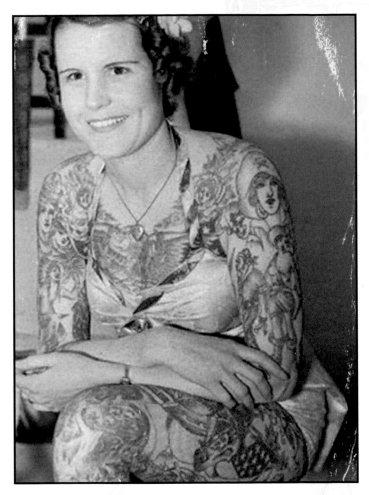

Betty Broadbent performed with the Ringling Brothers in the 1930s.

This book will provide you with a basic knowledge of the different styles of tattoo drawing and their influences, as well as basic drawing skills and techniques and more advanced projects to try using the tattoo styles featured. Have fun experimenting and aim to master your own unique tattoo drawing style.

Chapter 1
Tattoo style influences

The influences on tattoo designs are many and varied, and their roots can be traced back to different periods in history as well as geographical locations across the globe. An understanding of how these various styles have evolved will help your own tattoo designs.

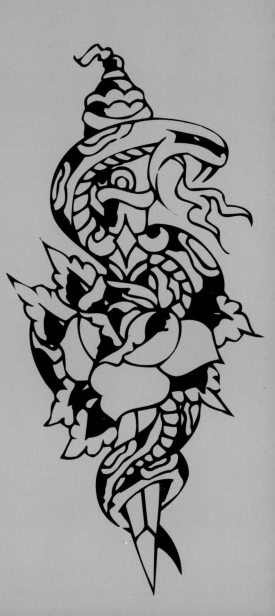

Old skool tattoos

The history of the tattoo medium is heavily indebted to the sailors who travelled the world and brought tattoo culture back to the West from their far-flung destinations. These seafaring-influenced designs are now known as 'old skool'.

Samuel O'Reilly's parlour

Samuel O'Reilly came to the New York City area from Boston and set up shop there as a tattoo artist in Chatham Square in the Bowery district. O'Reilly had patented the first tattooing machine in 1891 (patent #464,801) and, using this revolutionary machine, created a profitable business for himself providing tattoo work for countless sideshow folk as well as 'regular' people.

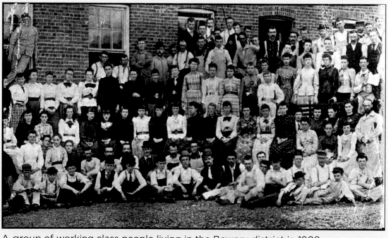

A group of working class people living in the Bowery district in 1908.

He took an apprentice named Charlie Wagner. After O'Reilly's death in 1908 Wagner expanded on O'Reilly's ideas and filed a patent of his own for a tattoo machine. He teamed up with Lew Alberts, a wallpaper designer who had transferred his skills to the art of tattoo design.

Alberts is noted for re-envisioning the majority of early tattoo flash art. While tattooing was declining in popularity across the country, the art form flourished in the Chatham Square district. Tattoo artists decorated their wives with examples of their best work so they could be virtual walking advertisements.

An early tattoo parlour in Virginia, USA, 1937.

Popularity

The Chatham Square parlour fell on hard times in the 1920s and the centre for tattoo art moved out to Coney Island. With veterans returning from the first World War, particularly those in the navy, there was an increased demand for images inspired by heroics and patriotism. Tattoo art began to flourish in areas near military bases.

Tattooing once again fell from favour with the American public after the second World War. By this time associated with biker gangs and hoodlums, its popularity was at an all-time low. With a outbreak of hepatitis in 1961 the industry was almost wiped out. While most tattoo shops had sterilising equipment, it was not in widespread use and a newspaper article credited to the *New York Times* linked blood poisoning, hepatitis and other diseases with these tattoo parlours.

New York City offered tattoo parlours a chance to self-regulate in the form of an association based on the Comics Code Authority, which sought the regulation of that other symbol of delinquency – the comic book – by the comic book publishers themselves.

However, the parlours were unable to form an organisation and the health department soon went after them; many were shut down due to violations. New York soon outlawed tattoos and the better stores moved to Pennsylvania, New Jersey and Connecticut, where it was still legal to receive a tattoo.

But in the late 1960s the image of tattooing got an overhaul, thanks in part to the media-savvy Lyle Tuttle. Tuttle was a charming man who tattooed many celebrities. He became the 'go-to' guy for newspapers and TV shows wanting more information on the art of the tattoo.

Lyle Tuttle was instrumental in bringing the art of the tattoo to the attention of the media.

Today, the popularity of tattooing is at an all-time high, and many tattoo artists are featured in gallery shows normally reserved for 'fine' or 'legitimate' artists. The art form has come full circle.

It's only natural, then, that the need for good tattoo design artists has exploded, and many fine art as well as commercial illustrators are providing designs for clients.

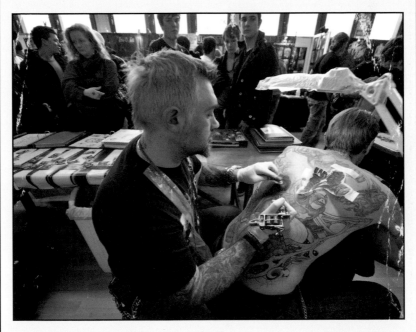

Tattoo enthusiasts around the world visit tattoo conventions to obtain inspiration for new designs. Here an artist tattoos a visitor with an image of comic-hero 'Hellboy' at the fourteenth edition of the Tattoo Convention in Geneva, Switzerland, in 2010.

Finding inspiration in reference

Images of mermaids, ships, pirates and all manner of sea creatures fall into the category of 'old skool' tattoo art, and many enthusiasts hope to capture the feel of vintage designs.

Flash books can provide a tattoo designer with inspiration, but understanding some of the basic patterns early tattoo designs followed will make your drawing attempts more successful.

Reference material is critical to finding the right look and the symbols and designs featured in this book will help you with this.

If you want to make your design appear vintage you'll need a somewhat 'straightforward' approach to the character's pose.

Because you cannot source real references for things that don't exist, you need to be creative in your thinking. If you're designing a mermaid, for example, you'll need some basic images to hand in order to compose your idea:

1. Mermaid drawings or artwork
2. Pictures of fish
3. Pictures of women in bikinis

Remember, it's important never to copy someone else's drawing. However, it's okay to look at it for inspiration and to ensure that you are getting all the details correct: for example, how does the human part of a mermaid attach to the fish portion? That can be answered by looking at someone else's concept art.

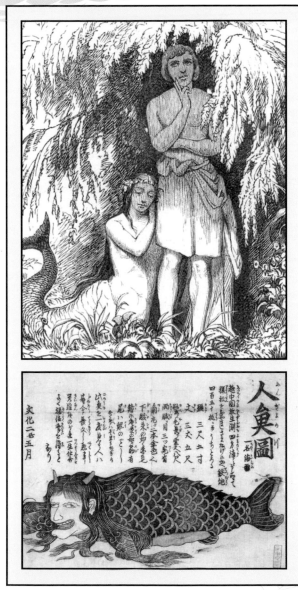

The Little Mermaid, an illustration by Vilhelm Pedersen for Hans Christian Andersen's fairytale.

Vintage Japanese illustration of a mermaid, with an emphasis on the grotesque.

 STYLE

Tribal tattoos

Tattoo designs have been influenced over the years by all sorts of cultures; their beliefs and fears. The tribal tattoo has had a huge impact on popular tattoo culture, especially concerning its preoccupations with death and superstition.

Amulets, talismans and protection

When the first Europeans arrived on the shores of the South Sea islands in the late sixteenth century, they discovered them populated by peoples with firm religious beliefs as well as faith that the universe was – if not controlled – at least influenced by an invisible force, such as karma. It was thought that the actions taken by a person could affect the way the universe reacted towards them.

With this belief in mystical powers, it's only natural that the people of the South Seas often adopted tattoos featuring symbols of protection – of amulets and talismans designed to guard and better influence the wearer's standing in life.

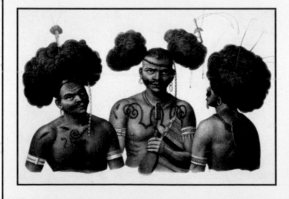

There are records that the inhabitants of the Pacific island of New Guinea wore tattoos, dating from the time of Captain Cook's explorations in the eighteenth century.

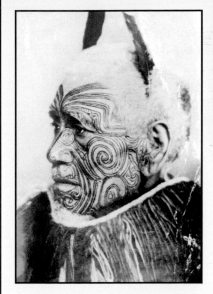

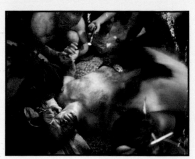

Above: Each *moko* (Maori facial tattoo) is unique and tells which *iwi* (clan) the wearer comes from, as well as carrying information about the various lineages and events of the person's life.

Left: It is said that the Maoris are the original tattooed people. This photograph from 1923 shows a Maori chief.

Tribal tattoos continue to be popular, often giving the wearer a feeling of warrior status. When these ideas are explored further – including the use of extensive symbolism – it can be seen that many tattoo clients are particularly drawn to an image that carries some kind of personal meaning for them.

Dating back to the sixteenth century there were examples of sailors adopting the cross and other icons of their religious beliefs as part of their tattoo designs, and this practice continues today. It was thought that by permanently displaying the elements of one's belief, there would be a connection to a higher power that would help to protect the wearer from harm in what was a very dangerous world.

Whether the wearer is a member of a club, a gang or even a roller derby team, allegiance and commitment to a group is often shown by having the group symbol permanently etched on each member's body.

Oriental tattooing

Historians believe that the earliest known accounts of Japanese body modification date from 10,000 BC. As Chinese travellers made their way across the island that would later become Japan, artistic and linguistic influences mixed and became intertwined.

By the time Japan came into its own in the fifth century, tattoos had developed a few different reputations. Chinese merchants noted that tattoos belonged to spiritual warriors, brothers in ink, and slaves (marked as property by their masters).

A tattoo design from the Edo Period (1600–1868) in Japan.

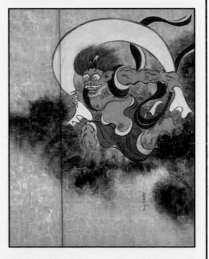

European painters were hearing about images of the 'floating world' or the *ukiyo-e* woodblock prints that were being produced. These rich, colourful images often depicted quiet moments with geisha, a landscape told in four seasons or various flora and fauna. But a good number of these prints were fierce swordsmen or heroic figures with tiger, snake or dragon tattoos streaked across their backs. *Ukiyo-e* prints possessed a fair amount of sensuality, which only

helped to make tattoos even more mysterious and taboo. As the popularity of *ukiyo-e* grew, so did the popularity of the tattoo. Patrons were going to woodblock artists and asking for the same images they had been attracted to on paper. Unfortunately for them, the only technique for drawing these images was the one the artists had been accustomed to for many years: carving into a wooden block. And so hours of painful and expensive ink application became a popular rite of passage for many men. The art of *irezumi* was born, and the unique colouration style of the woodblock prints would translate itself onto the body, like living art.

Tattoo artists were presented with the challenge of adapting these mysterious *ukiyo-e* images to the canvas of the human body.

Old Tokyo

Before Tokyo, the ancient city of Nara was the capital of Japan. Here, Nara Black (a special kind of printing ink) became famous for turning blue-green once placed beneath the skin. In modern Japanese, one writing of *irezumi* is 剳青, made up of the characters 'to remain' and 'blue-green'. *Irezumi* is the traditional form of applying ink by hand, without the use of any modern or electronic instruments. While this process is long and painful, it remains a revered art form today.

A ban on tattoos

During this time, the government outlawed the tattoo. For the old way of the samurai, this was unacceptable. The *ronin* (or master-less samurai) had given up their privileges, wealth and even native dialects under the new Western regime, but refused to be ashamed of their *irezumi*. As with all rebel endeavours, secret tattoo establishments opened around the entertainment districts of new Tokyo and Kyoto; they offered the perfect environment for the growing underground world of the new taboos – sex, alcohol and body art.

These shady entertainment districts of old Japan also saw the emergence of what would become a symbol of high culture: the geisha. It was well known in the eighteenth century that the streets of old Edo had a very active legalised prostitution business. However, the geisha were not glorified prostitutes. They offered the male population poise, poetry and beauty – an escape from tough and dirty street life.

Geisha

Many geisha swore that the idea of tattooing was unladylike and far from an elegant practice. However, some geisha fell in love but were not allowed to leave and marry, and in these cases the two lovers would share in *kishobori* – or a vow tattoo. These tattoos were often small and discreet, since female tattoos were not common. The man and woman held hands together and a small mark was made where each thumb was wrapped around the other hand. They were bound forever by this mark.

Some legalised prostitutes (*yujo*) would choose to have their lover's name or the *kanji* symbol for 'eternal' or 'life' tattooed inside their upper arm. Often these tattoos symbolised a deep, eternal relationship that in many cases was forbidden or extramarital. Some Japanese Edo scholars, however, have suggested that a few courtesans had a lover's tattoo just to keep a client, although that is a far less romantic idea.

Prohibition... and acceptance

During this tattoo prohibition, tattoos once again gained an anti-establishment reputation. The Japanese are known for the idea of *wa* (harmony), and the tattoo began to represent the dirty everyman of the old world, not the clean modern Japanese who were eagerly jumping into British naval uniforms in order to get along with their new neighbours. However, the Japanese who bore these images felt proud of their allegiance to the traditional imagery of an ancient culture.

The ban on tattoos was not lifted until 1945, when the American military occupied Japan at the close of the second World War. With the American occupation came Mickey Mouse, Superman, cigarettes, pin-ups and a new appreciation for the art of tattooing. Coming almost full circle, the West had both prohibited and accepted the idea of the tattoo within a century.

The Yakuza

For many Westerners, the thought of the Yakuza – the Japanese mafia – conjures images of full-body tattoos, dark sunglasses indoors and usually a missing pinkie. Born out of the feudal era, the Yakuza have

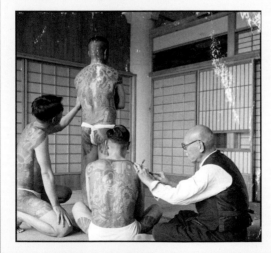

reputations as drug dealers, pimps and extortionists, while some say they are modern-day Robin Hoods, lashing out against a conformist society. Either way the tattoo designs that they wear with pride are fascinating examples of a tattoo drawing style.

A Japanese tattoo artist works with Yakuza gang members on tattoo designs.

Criminal tattoos

According to historians, the early Japanese government would brand criminals with forced tattoos. The horror of this wasn't in the act of marking itself, but where the criminals were branded. Sometimes these marks would be directly on the criminal's face – offering no return to normality after finishing a sentence. In many instances the actual name of the crime was tattooed directly down an arm or leg, a message to the world that there is no forgiveness from the government.

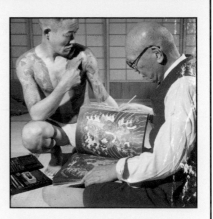

A tattoo master searches through reference images to find the right tattoo design for his client.

Yakuza tattoos

For a small number of Yakuza who leave the lifestyle, some open up tattoo parlours. Traditionally, Yakuza full-body tattoos do not completely cover the chest, feet or hands. In this way, the traditional kimono (which has an open fall at the chest) can be enough to cover them. Japanese customs don't allow boasting or self-praise; even when the top sumo fighter (*yokuzuna*) wins his championship, it can cause the nation to shudder if he should pat himself on the back. In this vein, even the Yakuza don't boast their own tattoos. The full-body artwork is said to be for self-satisfaction, and is revealed to other members for interest. Often worn as badges of honour, Yakuza gangsters sport massive *irezumi* unique to each mob family. Rumour has it that with each terrible crime they commit, they will tattoo a black ring around a finger. By undergoing these full-body tattoos the gangster is telling the world he is not afraid of the pain of the brutal sessions. Application of these tattoos traditionally was with crude, splintered bamboo shoots, pricking the skin literally hundreds of thousands of times, if not millions over the years of labour.

The Yakuza wield the 'fear of the tattoo' or 'fear of the *horimono*'. This means that no matter how a Yakuza may cover up a full-body tattoo, bits of images still find ways of sticking out, giving passers-by a sense of foreboding. Some public bath-houses in Japan may therefore refuse a customer with too many tattoos!

Yakuza women

In 2007, Shoko Tendo published a fascinating account of her life as the daughter of a Yakuza. It was called *Yakuza Moon: A Memoir of a Gangster's Daughter*. As interesting as the Yakuza are, just as interesting is the story of the Yakuza women – the girlfriends and wives of mobsters. These women were often pressured into receiving painful full-back *irezumi* tattoos as well, as a sign of their loyalty to their significant other or the entire mob family. Photographs of women in the middle of the *irezumi* process can be found dating to the turn of the twentieth century, and the practice still continues. In 2006 a convention in Tokyo included a speech by a woman who stated: 'When you get a tattoo, something you treasure for the rest of your life is added to your body forever. There is a feeling of joy to be had from that.'

This full-body tattoo features a water dragon motif once revered by eighteenth-century Japanese firefighters. *Irezumi* was traditionally associated with the Yakuza, and also with manual labourers. Today, it is also the ultimate fashion statement for Japanese youth.

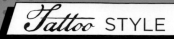

Tattoo design as fine art

Japanese painters and illustrators are influenced by both the old *ukiyo-e* prints of *irezumi* as well as the modern pop-culture scene. Artists, meanwhile, continue to exhibit their tattoo-inspired pieces in hip modern galleries, while the rest of the art world grows to accept *irezumi* as fine art. Art collectors all over the world are publishing books chronicling the modern *irezumi* practitioners and their paintings and sketches.

Japanese prints like *The Great Wave off Kanagawa* by Hokusai continue to influence Japanese painters, illustrators and tattoo designers the world over.

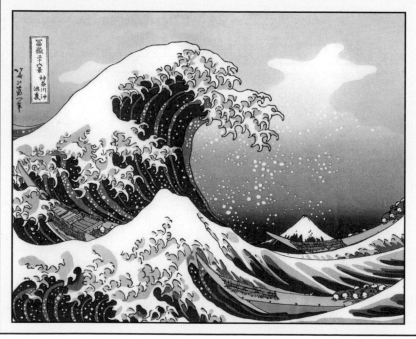

Horiyoshi III

If you're looking for the Holy Grail of Japanese tattoo work, you can find no better than Horiyoshi III. The third member of an honoured family of artists, Horiyoshi III took the title *hori* (to engrave) as his father had. Born in Yokohama in 1946, he studied the *tebori* and *irezumi* crafts of his predecessors, eventually coming to specialise in the same ancient hand techniques as the Edo period. Horiyoshi is known for doing just a few sketches for his clients, then inking directly from these notes onto the skin. His skill and reputation are so trusted that his clients are more than willing to hand over creative control to him.

Junko Shizawa receives a tattoo from Grand Master Horiyoshi, one of Japan's major tattoo artists, during a cultural event for the press. The tattoos represent imagery from traditional Japanese culture.

Specialising in full-body tattoos, Horiyoshi III depicts only the classic Japanese iconography of *irezumi*. His works have been collected in numerous publications, including his sketches of 108 heros of the classic Chinese tale *Suikoden* ('36 Ghosts'), and *The Namakubi* and *100 Demons*. These art books cover the process from sketchbook to photographs of the finished product. Although he is a modern artist, Horiyoshi draws directly from the ancient art style of *ukiyo-e* prints, often depicting angels, koi, dragons and cherry blossom.

Full-body tattoos are likely to cost tens of thousands of pounds and take many years to complete. It is important for the artist to weave each work session into the next, so the ultimate design does not look like separate pieces, but a tapestry of images completed in one sitting.

The influence of the macabre

Skull images play a big part in tattoo design. There are a lot of theories as to why they are so popular. One is that they represent the face – something everyone spends countless hours studying on their friends, co-workers and family members.

Skulls also represent death, and, whether we like to admit it or not, we all have a certain level of fascination with death. It's the one thing everyone has in common – and what better symbol of death than a skull?

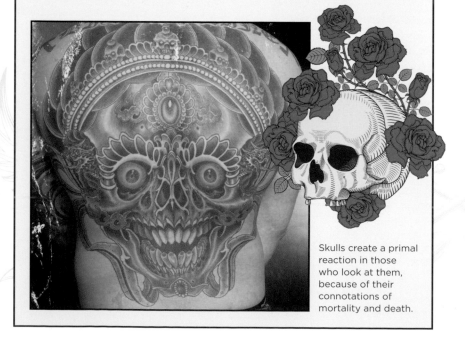

Skulls create a primal reaction in those who look at them, because of their connotations of mortality and death.

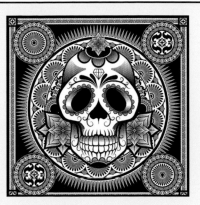

Many cultures combine the skull symbol with bright decorations, and consider the symbol of death a way to commemorate the life of those departed.

Fear of death is often faced by confronting it head on – so a design incorporating a skull clearly allows the wearer to do just that. Many designs are more cartoony, allowing the wearer to laugh at death. Some cultures go even further than confronting death and use the skull as a symbol to be ornately decorated for events, for example the Day of the Dead in Mexico.

The tradition of decorating skulls with patterns and other festive symbols shows that the community sees death not just as an end to life but also as a way to memorialise lost family and friends. By taking this more positive approach, the cultures show a healthy respect for death not as something to be feared, but as something to be embraced and even a cause for jubilation.

Mexican children often make sugar skulls. By combining water and sugar in a pre-fabricated skull-shaped mould they can create a base that can be decorated with elaborate paints or food colourings along with simple jewels. This can then be displayed as part of the celebrations.

Fear and nightmares

Although tattoos mean different things to different people, designs based on fears or nightmares are generally viewed as being pretty extreme. Perhaps the most primal of all fears is the fear of death.

The Grim Reaper

The Grim Reaper that Western cultures have come to know is usually depicted as a skeletal figure draped in a black cloak and hood carrying a scythe, and it has been around since about the fifteenth century. English legend avers that the Reaper is able to cause the victim's death either by touch or just being in his presence. This idea has been explored in literature, in tales where the intended victim is able to outsmart or pay off the Reaper, thereby avoiding their fate.

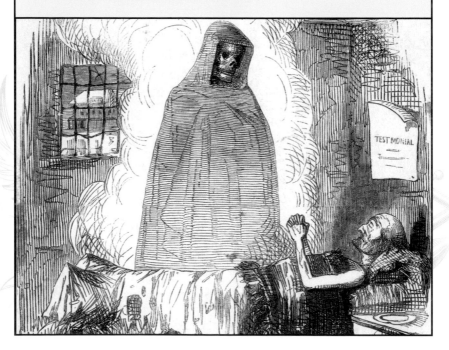

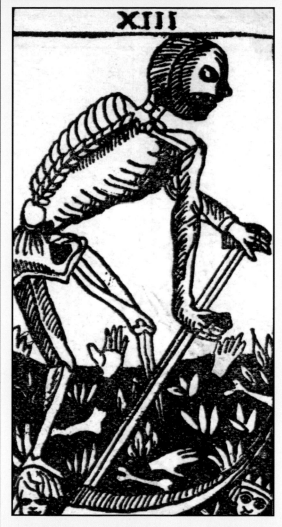

XIII

Death is not always depicted in such a grim manner. Some cultures, including Ancient Greece, considered death to be the inevitable end and not a sinister and evil figure. They therefore often depicted him as an old man with angel wings or even as a young boy.

An undated woodcut of the Grim Reaper. Studying heavy linework like this can be good inspiration for your tattoo-style drawings.

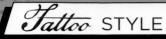

Horror tattoos

Most horror tattoos take elements from all of the sources mentioned, creating unique nightmarish visions of both the past and the present – and offering their fans a particular take on some amazingly horrific subject matter.

The success of George Romero's *Night of the Living Dead* in 1968 – a small film that built up a cult following – may seem fairly recent, but zombies and zombie culture have been around for many years before that, both in literature and in films such as 1932's *White Zombie* with Béla Lugosi.

There is little more frightening to most people than the idea of a friend or loved one coming back from the dead intent on eating your brain.

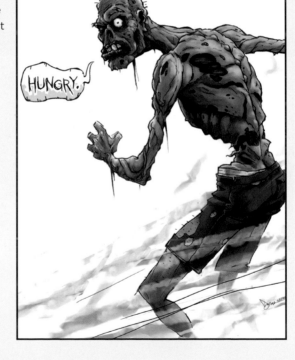

Zombie illustration by artist Derek Ring.

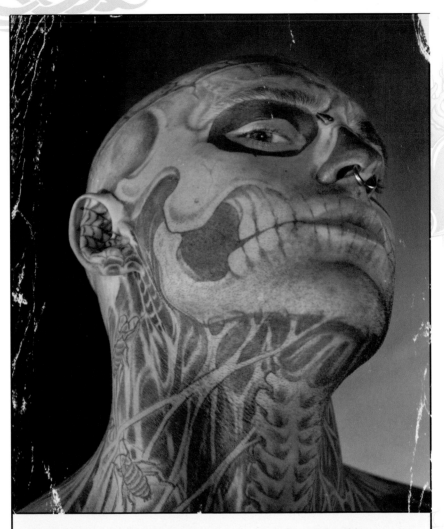

This 22-year-old man has tattooed his whole body and face to resemble a zombie – a walking, decomposed corpse. He spent more than 24 hours under the needle.

Nautical imagery

The sight of the Jolly Roger flag sent a shiver of fear down the spine of many a sailor, letting them know that they were being approached by a lawless band of attackers. The Jolly Roger has come to symbolise anarchy or lawlessness even today.

The Jolly Roger, depicting a skull over crossed bones or sabres, goes all the way back to the roots of tattooing. Its striking image conjures thoughts of both rebels and swashbuckling adventure on the high seas.

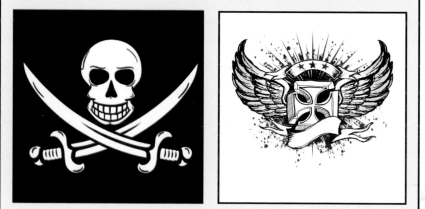

A variation on the Jolly Roger was adopted by many underground motorcycle clubs in the 1950s, further cementing its bad-boy status.

The Jolly Roger was created by French pirates who originally flew a bright red flag (or *lie rouge* – meaning 'pretty red') to let the ships that they were chasing know that they intended to take no prisoners nor show any mercy. The symbol filled any opposing crew with fear. The hope among

the pirates was that this fear would be strong enough that the captain and crew of the assaulted vessel would give up their cargo without risking a fight to the death.

Lie rouge eventually evolved to 'Jolie Rouge'. When British and American pirates adopted the concept they altered the image to the symbol of the Grim Reaper and adapted the phonetic translation to Jolly Roger. Following the example of the French pirates who gave no quarter to the vessels they chose to attack, use of the Jolly Roger flag communicated the need to surrender or die by all those who faced it.

Variations on the Jolly Roger subsequently occurred as groups of pirates attempted to distinguish themselves with their own unique take on the fearsome image.

The history of pirating is complex, and there were many instances of governments or royal families contracting 'private ships' to attack and give chase to enemy ships. Pirating was allowed in certain areas provided proper respect was shown to a nation's own fleet. Pirates who attacked any ship they came across soon earned a price on their heads and ended their careers with a noose around their necks.

In the second World War the Jolly Roger was commissioned by British forces, which adopted it for their Royal Naval Submarine Service – often flying the image as a symbol of a successful combat mission.

In America the Jolly Roger was often seen in conjunction with the Air Corps and appeared on fighter squadrons during the second World War.

Today, although it remains in use by the British Submarine Corps as well as on some US military hardware – notably scud missiles – its most common usage is to warn about a substance being poisonous.

Chapter 2
Drawing basics

There are some basic techniques that can help you overcome any technical struggles you might have. This chapter guides you through the essentials, and the step-by-step techniques at the end of the chapter will teach you to execute the more advanced design projects that follow.

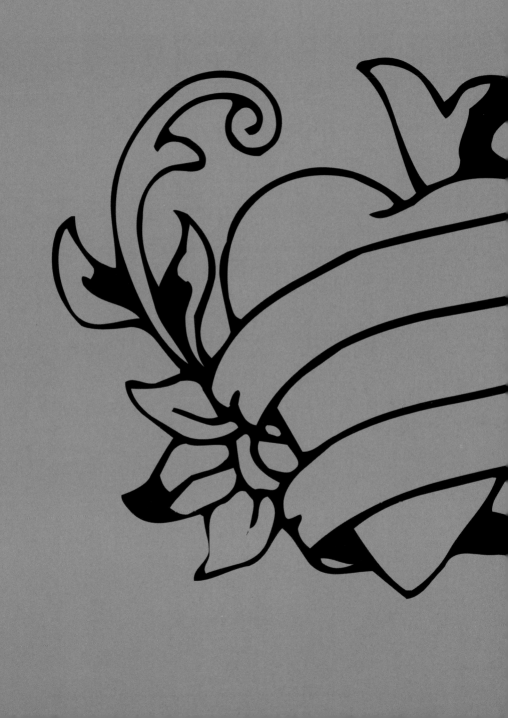

Tattoo STYLE

Your kit

Imagine your art lasting for ever – always on display. This is the difference between a piece of tattoo art and something that might hang on someone's wall. That's a lot of pressure on an artist to 'get it right'.

Since you'll be producing designs and drawings for someone else to apply to your client you'll want to make sure your work is simple, clean and very clear to understand. Here are some of the essential tools you'll need to get the job done:

You will need

1. Flash book for reference – a book of popular tattoo designs and styles.
2. Pencils both for drawing and colouring.
3. Pens for details.
4. Brushes or brush pens.
5. Ink.
6. Paper – Bristol board for final illustrations.
7. Tracing paper for corrections and clean-up.

You also need a comfortable, well-lit place to work. Whether it's an actual studio space, a room set up in your home or a kitchen table, you'll want to make sure you have at least the basics to create a good work environment and ensure the most professional results.

The three primary elements are a good chair, a strong lamp and a table slanted at an angle (usually between 30 and 45 degrees), There's a very good reason you want the table slanted. If you draw on a flat surface the image will often be distorted, but if you work at an angle this problem is virtually eliminated.

Working in a professional environment will produce professional results, so get the best equipment you can.

Thumbnails...

Creating thumbnails can be the art of the first (and second and third) draft to establish basic composition, balance and tone. Trying to come up with that ingenious design takes a few tries – sometimes even more than that – and too many people just jump right in to the drawing without giving it enough thought. It's amazing how many people seem to think they have to nail it on the first try. This is where the thumbnail comes into play. A thumbnail is a small drawing, on which you can work out details like character poses, facial expressions, the placement of any text and any other details that will make or break your illustration. Don't get discouraged and don't get lazy – work it all out at thumbnail stage and resist the temptation to 'figure it out' on the final composition.

The thin blue line

Some artists prefer to use non-photo repro blue pencils to do their layouts. These are technical pencils with a special lead – it's not just a blue pencil; non-photo lead will not reproduce when it is printed and it's easy to eliminate if you do your own scanning. Non-photo repro blue pencils and graphite pencil lead (for mechanical pencils) come in a variety of grades, some soft and some hard. A soft lead is good for loose sketching while a hard lead is great for details.

The nice thing about using a non-photo pencil is you don't have to erase the pencil lines since they are easy to eliminate.

If you're drawing with a softer lead you want to be careful that you aren't bearing down too hard with the pencil. The line should be delicate, as if you were drawing on the side of a balloon – press too hard and it pops. Pressing too hard on paper creates grooves in the surface which are impossible to erase with a regular pencil eraser, and can create shadows that a scanner will pick up even with blue lead.

If you find you are constantly drawing too small, try this technique: instead of resting your hand on the paper when you draw, try holding the pencil sideways.

Much as you might hold a paintbrush, try keeping your hand up off the paper and using your whole arm to draw with – this allows you to get much larger, more dramatic construction lines that you can build on.

This will work if you're using a regular pencil too, and it's a technique that can be good when you're beginning the layout of a drawing.

Proportion

Understanding human proportion takes practice and observation. If you are going for realism it'll help you to take as many life-drawing classes as you can – you might even find open life-drawing sessions where artists can drop in and draw a model from many different angles.

Avoiding distortion

Regular human figures are eight heads tall with the centre point of the figure being roughly where the legs connect to the torso.

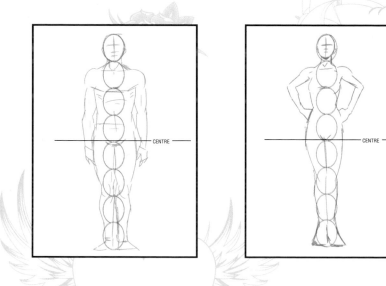

Note that the hands fall just about a third of the way down the thigh. Shoulders are generally two heads wide.

A male figure tapers in slightly at the waist (we are talking ideal figures here!) while a female figure tapers in more dramatically about halfway down the torso, giving her that famous 'hourglass' figure.

The best way to draw the figure is using the ball and cylinder method – this will allow you to 'move' the figure into different poses while maintaining correct proportions. By having this figure guide you are able to reposition the figure in any pose you want. The same guide applies to various popular tattoo subjects and getting to grips with it now will help you to draw proportional fairies, mermaids, angels and superheroes.

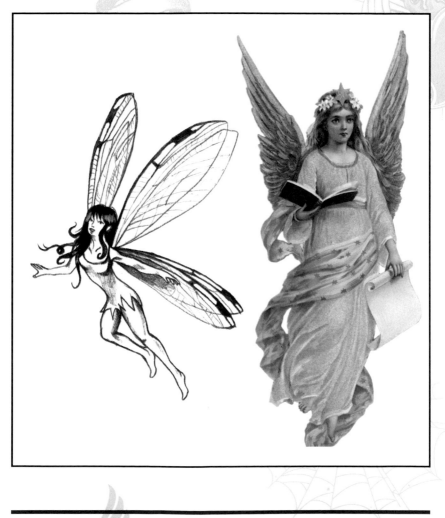

Perspective and foreshortening

A whole book could be filled going through the technical aspects of perspective and foreshortening but a basic understanding is crucial for every artist and mastering this level of understanding now will help you later on to design tattoos that jump out from the skin and have form, for example a tiger's claw reaching out of a tiger tattoo.

There are three basic styles of perspective; one-point, two-point and three-point (we could go on, but these are the basics). You'll need to get your head around basic two-point perspective if your tattoo drawings are going to be effective. It's used to make a drawing appear three-dimensional and gives a representation of an object as it is seen by the human eye.

Foreshortening is a similar concept. It makes an object or distance appear shorter than it really is because it is angled towards the person observing it.

FORESHORTENING TWO-POINT PERSPECTIVE

2-POINT PERSPECTIVE

LVP

RVP

HORIZON LINE

Tools you need

Gather together a sharpened hard lead pencil, paper and ruler (either a metal one or one with a metal edge). A light-coloured pencil is also a helpful option, but it's not essential.

All perspective styles share two common elements:
- A horizon line or point of view (POV) line.
- A vanishing point (or multiple vanishing points).

How to use foreshortening in tattoo drawing

To make your design 'pop', foreshortening can be used in a number of ways. Look at photos to get inspiration for your own tattoo designs. Giving an illustration a foreshortened angle, for example, adds drama and movement to the image, as well as adding depth.

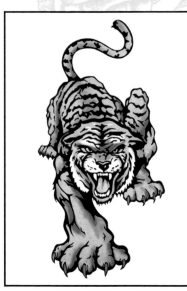

Big cat tattoos are often given this treatment. The inspiration is taken from nature and the tattoo designer caricatures the animal's attributes in order to emphasise them.

Drawing people and animals

The world is made up of shapes. No matter how complicated the object you are trying to draw, if you break it down into basic shapes it will be easier for you.

A good way to approach people and animals (animals are very popular tattoo designs) is to start with stick figures and work in the shapes from there. With a little practice you'll be drawing like a pro in no time – it's just a matter of sticking with it.

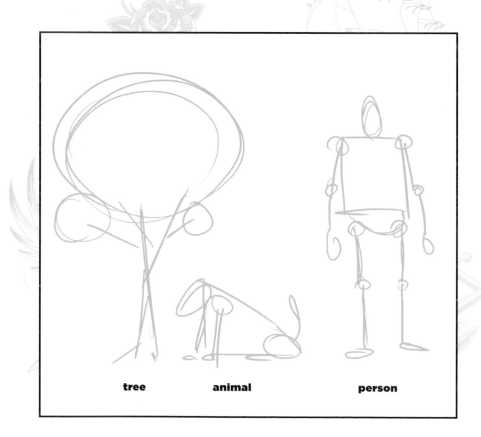

tree **animal** **person**

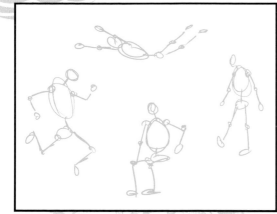

Make sure if you're drawing people that you vary the shapes and sizes – if you don't you run the risk of your people looking like they were made with cookie cutters.

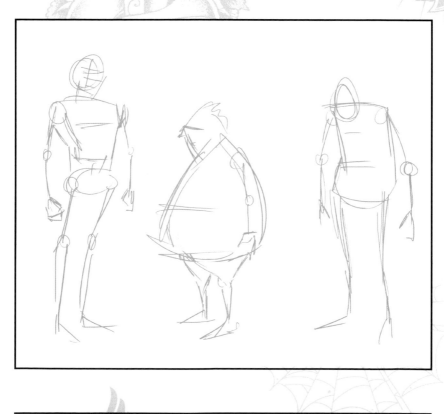

Drawing styles

You've got the basics in drawing skills, so the next step is to find your style. There are some simple steps you can use to try drawing in a variety of styles – then find the one you are most comfortable with and try to stick with it. That's the secret to becoming a better artist.

Japanese style

This is a broad term and may mean mimicking the fine, delicate lines of the old masters or the broad, confident brushstrokes found in *kanji*.

Try working with a brush that has a medium-length tip. A brush can give you rich, fluid lines if you slightly increase the pressure you place on it. These thin-to-thick-to-thin lines are unique to brushstrokes.

 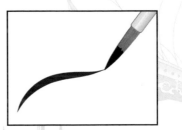

Using a brush is the most effective way to create work with a Japanese feel, but learning how to draw with a brush takes practice. A brush is different from a pencil or pen, so it'll take a bit of practice to get the lines you want.

Get yourself some good ink and dip the brush about halfway up the bristles. Make sure you aren't hitting the bottom of the inkwell with your brush because the tip will pick up the sediment that can settle at the bottom of the ink. Wipe the excess ink off the brush onto the lip of the ink bottle and start making some brushstrokes. Bring the brush towards you when you work, turning the paper as you go to control the line direction.

TIP: If your ink is putting down a line that is more grey than black, you might have too much water in it. Always dry your brush after you rinse it off so that you aren't adding water to your ink.

Kanji style can be created in this way, but using broader brushes or calligraphy pens – it's important to study the brushstroke of your reference to master the design.

Look at the *kanji* symbol (like the one on the right) and try to break it down by shape. This is the *kanji* symbol for 'artist'; if we break it down step by step we can see how it is simply a matter of getting a series of smaller shapes right and putting them together to give you the complete symbol.

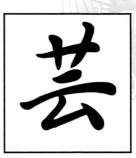

The important thing to note is the tapered nature of the linework and the fluid lines. Try practising just the shapes that make up the separate lines before you attempt to put them all together.

Kanji 'artist' project

Step 1: For a simple horizontal brushstroke, start thin and spread out your brush as you go by applying more pressure.

Step 2: Add a vertical brushstroke, starting with a bit of a sharp hook at the top.

Step 3: Add a second vertical brushstroke, almost identical to the first. The image now looks like a stylised 'H'.

Step 4: Now we need another horizontal brushstroke – this one is longer than the first one.

Step 5: Starting just shy of the centre, a little bit to the left, add a kind of 'L'-shaped squiggle that stops about halfway from the line above.

Step 6: Now add a 'hat' to the L, which runs vertically, starting thin at the top and going thicker. It looks like a beret on a coathook. When drawing *kanji* it's essential to get the details right.

Cleaning your brush

Cleaning your brush is crucial to extending its lifespan, but never leave a brush in water or cleaning fluid. This will cause your bristles to bend, and bent bristles are impossible to fix.

Instead, dip your brush in some clean water and swirl it around a bit, making sure the brush itself doesn't touch the bottom of the water bottle. Then wipe the brush in one direction from the base of the brush upwards to dry it.

You should rinse your brush like this about every 10–15 dips in the ink. When you are finished you should wash your brush thoroughly:

1. Hold your brush under some warm running water.

2. Catch some of the water in your other hand and mix in a tiny bit of soap. Now put the brush in your hand and spin it around gently.

3. The water in your hand will start to turn black as the ink comes off your brush. Replace the water in your hand with some fresh water and a bit of soap and repeat the process. Do this several times until the water stays clear.

4. Now hold your brush under the running water for a minute, turning it.

Store the brush with the bristles pointing upwards in a cup or pencil holder and it'll be ready to go when you need it again.

TIP: Brushes come with clear plastic tubes to protect the bristles when you first buy them but if you lose them, try taking a straw and cutting it into shorter lengths to use as brush protectors (as long as the brush fits inside the straw – which most will).

More drawing styles

Japanese drawing styles tend to be fairly stylised. You may be more inclined to draw in a realistic manner, and this can also suit particular kinds of subject matter especially well, such as likeness of a person, as shown below. Other suitable subjects for a realistic treatment may include animals or plants.

Realistic style *by Jane Laurie*

The key to successfully rendering something in a realistic style lies in using appropriate reference material.

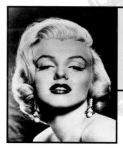

Find a photograph of the thing you want to draw. For this example, Marilyn Monroe is the reference. This photograph makes a good base for a memorial tattoo.

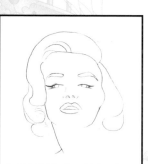

Lay a piece of tracing paper over the photograph, and tape it in place. Using a sharp pencil, draw around the edges of the entire face, and then pencil in the linework of the features.

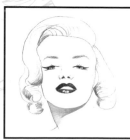

Following the photograph, start by shading in obvious light–dark contrasts in the features.

Pick out finer details, and refine the pencil lines, such as hair details, eyebrows and lighter shadow areas.

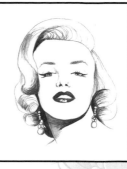

To make this drawing into a memorial tattoo, choose some simple decorations. For example roses (see pages 80–81) and a banner (see pages 70–71).

It might take a few attempts to get all of the elements working. You might need to draw the elements separately and then trace over them to make the finished composition.

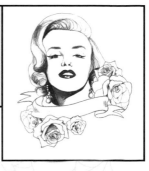

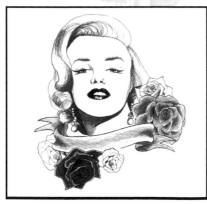

Memorial tattoos often work well with just a touch of colour; you could use inks or coloured pencils. The choice is yours – you might prefer it simply as black line.

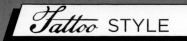

Cartoon style

The term 'cartoon' encompasses a broad range of styles. It can be used to refer to an animated cartoon character, or it may mean a caricature or an inanimate object where an artist exaggerates certain features to create an overall style. The first rule of drawing cartoon-style is to always keep the linework simple.

Ice cream cone *by Allison Bamcat*

This is a simple design that uses a cartoony, fun style. It fights cliché and goes against the grain by taking an everyday object as its inspiration and turning it into an obvious symbol of femininity.

Step 1: I created the basic sketch in blue pencil lead, working out the shapes and patterns, as well as the flow of the ice cream, without making the marks too dark.

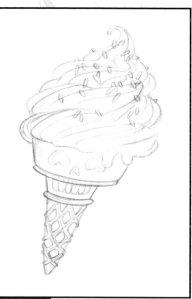

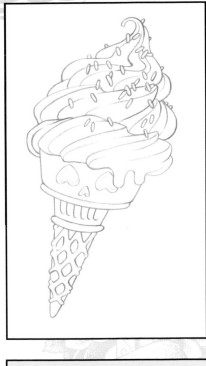

Step 2: After that I went over my original sketch with a regular mechanical pencil, finalising the lines I was happy with.

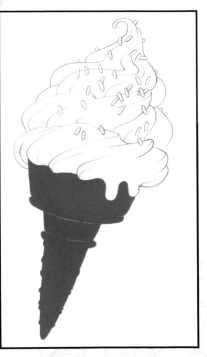

Step 3: I then created a copy of my image (to avoid working on the original) and with a mechanical pencil traced the image onto Bristol vellum. After that, I started painting my base coat for the cone.

Step 4: I finished painting the cone, working up the lightest highlights. I then moved onto painting the ice cream, trying to create a two-toned effect.

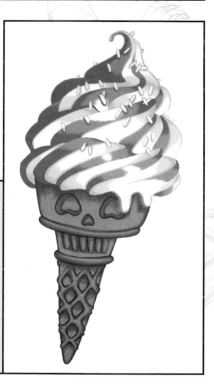

Step 5: Happy with my pinks, I took a light green for the rest of the ice cream to make it look like a rainbow.

Step 6: I added another, lighter mint-blue to the green, and then moved to the sprinkles.

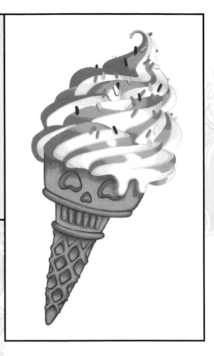

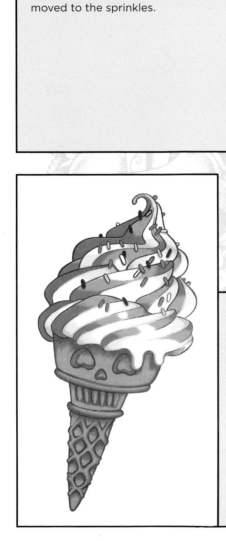

Step 7: Finally, I took a small pointed watercolor brush and black waterproof ink to the ice cream to allow it to 'pop'.

Old-skool style *by Jane Laurie*

The important thing to remember when trying to draw in an old-skool style is to keep things looking vintage, and that means maybe even just a little bit crude.

Step 1: Have a look at some photographs of pin-up girls. There are lots of illustrations from the 1940s to look at too. Print out a couple of images to get a good feel of the poses and style.

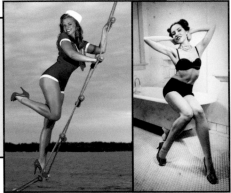

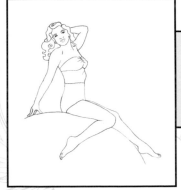

Step 2: You can trace one of your print-outs exactly, or you can make up your own pose if you wish. Use a light pencil line to make the basic outline first.

Step 3: Use a black fineliner to ink in the lines. If you want to alter anything from your original, do it here. In this example, the mouth was changed slightly to make it slightly more cartoony.

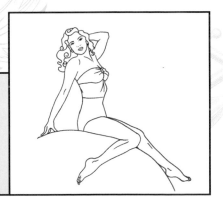

Step 4: Using ink, paint or coloured pencils, lightly fill in solid areas of hair, lips, skin and clothes.

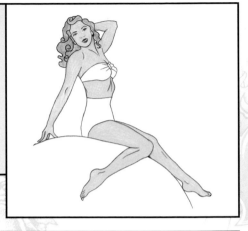

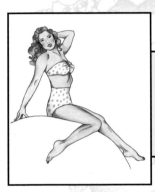

Step 5: Pick out important details, such as cheek highlights, nail polish and the bikini pattern. Also, add some shading to skin, clothes and hair. Don't go overboard though: this style is meant to be simple.

Step 6: To make a full tattoo design, add other elements such as banners (see pages 70–71) and stars (see pages 66–67). If using Photoshop you can also overlay an old paper texture for an extra vintage touch.

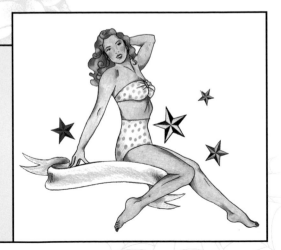

Biker style

Often the name of a biker club or some other affiliation is worked into
the design of this kind of tattoo, but essentially any old skool art with an
attitude will give you this style.

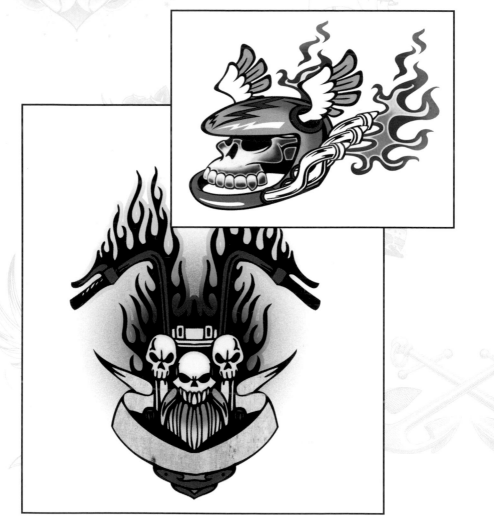

Line art style

Line art has stark contrasting lines, usually with broad brush-style strokes.
This helps to give the piece a vintage feel.

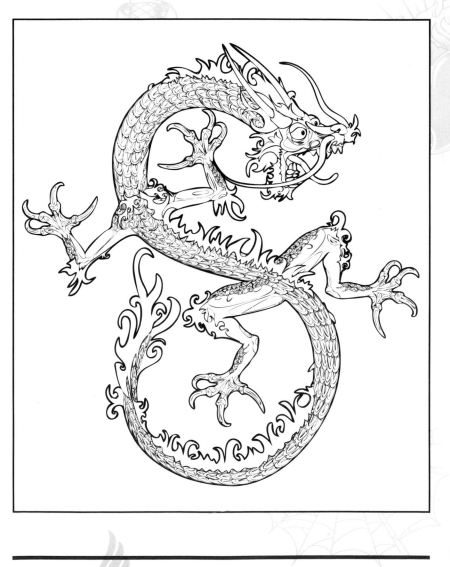

Tribal style

The patterns used in tribal-style tattoos can be created simply by breaking the design into shapes. Unlike *kanji* style (see page 49), you need to make sure you keep the ends of the lines even, and don't utilise brushstrokes to give tapering lines. The lines should remain consistent throughout to give an almost mechanical feel to the design.

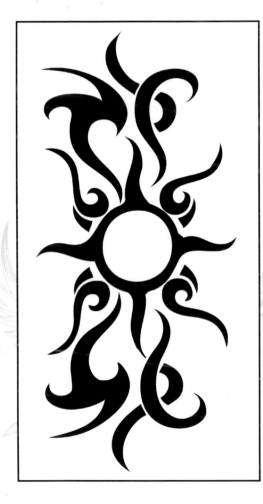

While it's true that the linework on this tribal tattoo tapers and flows, it does so in a more even and mechanised style than the loose brushwork of the *kanji* style.

We can see the evenness of the line more clearly when we examine the shapes themselves without the colour filled in.

How to...
Draw a skull

Step 1: Start with a circle; keep it loose. Extend the jawline down and then divide the face in half vertically and horizontally. The other horizontal lines are marked off to show where the nose and mouth will go. Loosely sketch in the cheekbones.

Step 2: Lightly sketch in the eye socket shapes, the nose and the teeth. Emphasise the brow ridge a little bit to give the skull some attitude.

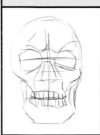

Step 3: Tighten up the sketch a little bit more – filling in the black areas and adding some more texture lines on the forehead and around the mouth.

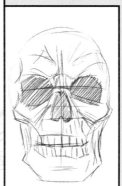

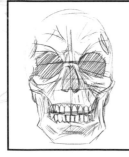

Step 4: Work out any extra details, especially with the teeth. The more you figure out here the easier it's going to be when you ink the drawing.

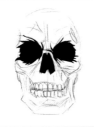

Step 5: Fill in the large black areas with a brush and some Japanese ink.

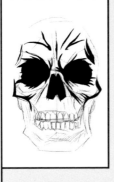

Step 6: Use a brush for this stage; you can use broad strokes on the cheekbones and on the brow. There's much more energy when you work with a brush than if you were to do this with a pen.

Step 7: Work in the details of the teeth as well as the lines on the upper lips and cheekbones.

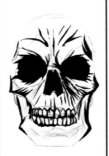

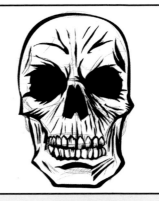

Step 8: Finish up the outside lines around the skull, the jaw and the top of the head.

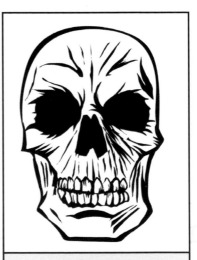

Step 9: Final step – erase all your pencil lines.

How to...
Draw an eight-pointed star *by Jane Laurie*

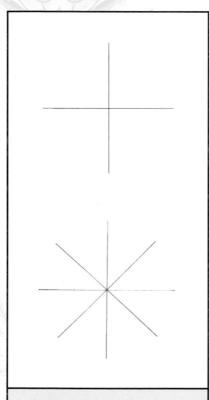

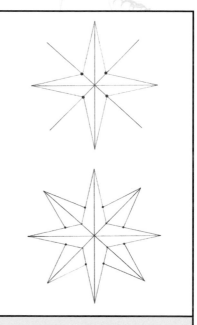

Step 1: Lightly draw a cross of equal proportions.

Step 2: Draw another cross intersecting the first cross at 90 degrees.

Step 3: Make a light dot 2.5 cm (1 in) out from the centre of the second cross (marked in red). Draw a line from each of these dots to the nearest point of the first cross.

Step 4: Mark a light dot 2.5 cm (1 in) up from the the corner of each of the points of the first star (marked in red again).

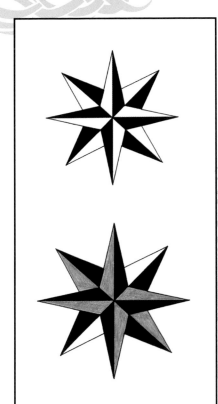

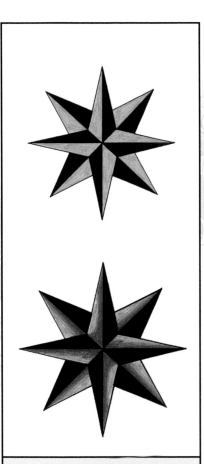

Step 5: Go over all of the lines in black ink or thick pen. Fill in the right-hand triangle of each point in solid black.

Step 6: Fill in the remaining blank triangles with a colour of your choice.

Step 7: Choose a darker shade of the same colour and lightly grade out from the inside long edge of each coloured triangle, to achieve a three-dimensional effect.

How to...
Draw a symmetrical heart

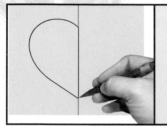

Step 1: Take a piece of white paper and draw a light line vertically down the middle. From the centre line, draw a line up and then curving over as if you were going to draw a circle, then straighten the line out as it meets the centre line again.

Step 2: Place a piece of tracing paper over the image and tape it securely in place.

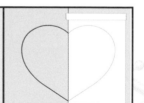

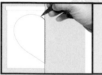

Step 3: Using a soft lead (2B or softer), trace the half heart shape onto the tracing paper.

Step 4: Untape the tracing paper, flip it over so the pencil line is face down on the paper and re-tape it so that the second half lines up with the first half.

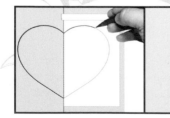

Step 5: Now trace on the back of the tracing paper. This will transfer the soft lead on the other side onto the paper. Be careful not to press your hand on the paper as you go because it will cause smudging.

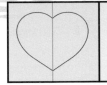

Step 6: Carefully peel off the tape and lift the paper off – you now have a perfectly symmetrical heart. Don't throw the tracing paper away... yet.

Step 7: Take the heart and go over the pencil lines with ink, then erase all the pencil lines (including the centre line). Take some white paint and fill in the heart to make it stand out on your coloured paper.

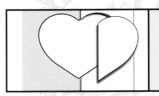

Step 8: Here's the clever part. Take the tracing paper you just used and carefully cut out the heart shape with some sharp scissors. Now you have a half-heart-shaped stencil.

Step 9: Place a small fold of tape underneath the stencil and position it right on one half of the heart. Then using a broad brush and some black ink or paint dab some colour on top of the stencil and onto the paper. Be careful that the stencil doesn't lift up while you're working. Carefully lift the stencil up, making sure the ink has dried, reverse it and do the same on the other half of your heart drawing.

Step 10: Voila! The stencil protected your heart drawing and now the extra black ink really makes it stand out.

How to...
Draw a scroll or banner

Step 1: Draw out a rounded half box in light pencil. This will be the main part of your banner.

Step 2: Draw a 'flag' effect by having the end curl under.

Step 3: Extend the flag another level.

Step 4: Using a slightly darker lead pencil, start to work out the details of the banner. This is a ragged, old skool-style banner, so sketch in some rips and tears.

Step 5: Tighten up the lines a little more and add a bit of shadow to the folds.

Step 6: Add stress marks to give it a real weathered look. Now, just like you did with the heart exercise on pages 68 and 69, use some tracing paper to copy and flip the drawing.

Step 7: After you've transferred the other half you'll need to go over all the pencil lines to tighten it up a bit more. This should not be perfectly symmetrical so work the rips and tears freehand in different parts of both sides.

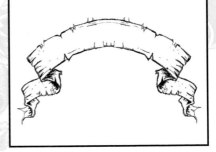

Step 8: Ink the pencil lines and you've got yourself a nice-looking banner illustration!

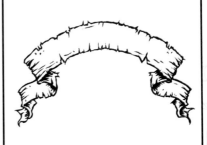

How to...
Draw a spider's web

Step 1: Start with a cross in the middle of your paper, divided into four even parts.

Step 2: Tilt your paper at a 45-degree angle and draw another intersecting cross, which divides your image into eighths.

Step 3: Now pick one of the sections and draw a semicircle connecting the ends of the lines.

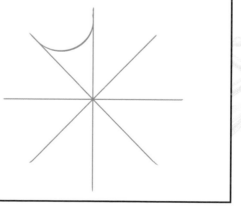

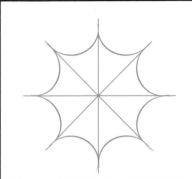

Step 4: Do this for the other sections; try your best to keep them evenly spaced, connecting the edge of one semicircle to the next until you have the exterior perimeter filled.

Step 5: Now repeat this same process about a third of the way into the centre of the web, going all the way around and connecting the edges.

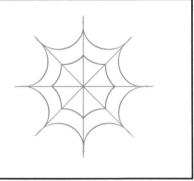

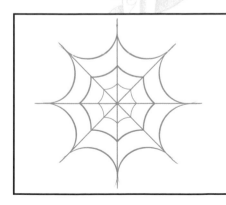

Step 6: Go one last time, moving in another third, and you have a spider's web!

How to...
Draw a pirate ship

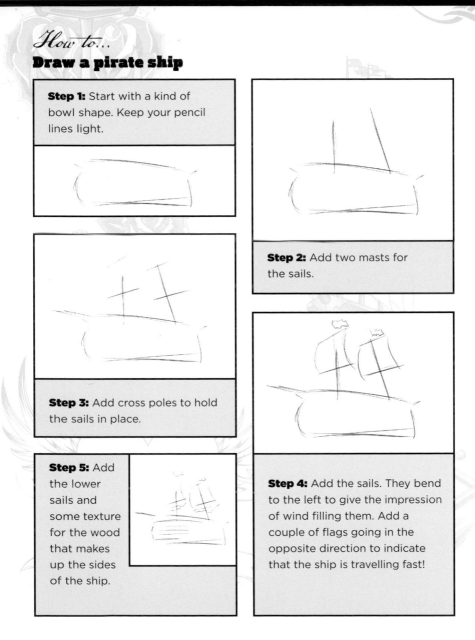

Step 1: Start with a kind of bowl shape. Keep your pencil lines light.

Step 2: Add two masts for the sails.

Step 3: Add cross poles to hold the sails in place.

Step 5: Add the lower sails and some texture for the wood that makes up the sides of the ship.

Step 4: Add the sails. They bend to the left to give the impression of wind filling them. Add a couple of flags going in the opposite direction to indicate that the ship is travelling fast!

Step 6: Draw the ratlines; those are the ropes that rise up the mast. Add a flag to the back of the ship so you can fly the 'colours'.

Step 7: Ink the piece using a brush. Use heavy black on the ship's frontage, sparing the white lines to indicate that it is made of wood. Ink the sails carefully from the bottom up with a heavy feathering technique to make the boat seem to be sailing towards the sun.

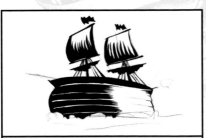

Step 8: Ink the lower sails and the ratlines.

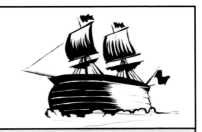

Step 9: Continue to work in the details. Use solid black areas to give the impression of light and shadow and make the image appear more finished.

Step 10: Erase the pencil lines and you have a pretty good pirate ship!

How to...
Draw an anchor

Step 1: Draw a stretched-out cross – add a hollow oval shape to the top.

Step 2: Add the bottom plate, loosely built like a smile, tapering at either end.

Step 3: Add the anchor points, which are essentially just triangle shapes at the ends of the bottom plate.

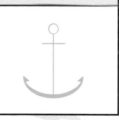

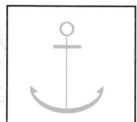

Step 4: Bolden up the horizontal lines a bit more, to give the anchor some weight.

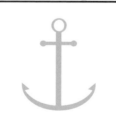

Step 5: Bulk up the main vertical, too. Add two circles to the ends of the cross.

Step 6: Ink the lines around the anchor, then erase your pencil marks.

Step 7: Add shadow lines to one side of the anchor to give it a sense of depth. Here, tiny triangle shapes create a geometric, stylised look.

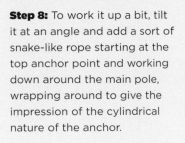

Step 8: To work it up a bit, tilt it at an angle and add a sort of snake-like rope starting at the top anchor point and working down around the main pole, wrapping around to give the impression of the cylindrical nature of the anchor.

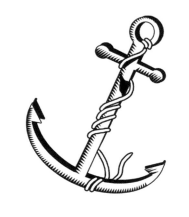

Step 9: Add a banner to the top (taking the banner from pages 70–71) – a perfect opportunity to make a sailor's grave type of memorial design. You could also add skulls or chains to dress it up a bit more.

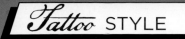

How to...
Draw a horseshoe *by Jane Laurie*

Step 1: Take a look at a photo of a real horseshoe. You are going to stylise it quite a lot so you don't need to copy it exactly – just use it for inspiration. If you want your horseshoe to be a good luck symbol, make sure it is turned in a 'U' shape – this is for 'catching' the luck in.

Step 2: Draw your basic horseshoe shape outlined in pencil.

Step 3: Add some detail to the inside, such as the holes where nails would go, and a lip on the bottom.

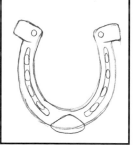

Step 4: To make your horseshoe into a proper tattoo design it is worth considering other embellishments to add to it. In this example, cherry blossom flowers and a banner (see pages 70–71) are used, but you can use anything you like; roses, birds, stars, dice, flames, a clover leaf...

Step 5: If you have been drawing the elements separately, you will now need to arrange them around your horseshoe. You can do this by cutting out each piece, arranging them all, sticking into place and then scanning the whole thing. You can also do it digitally with Photoshop if you wish. Once happy with your layout, you now need to refine all your lines with a bold black marker pen or ink.

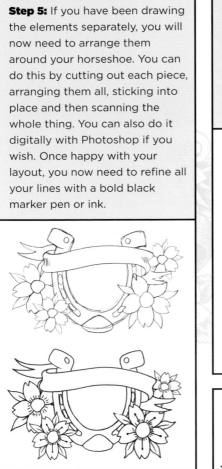

Step 6: Now you need to add colour. You can use coloured pencils, ink, paint or digital colouring. Add a light base colour to each element first, and then add more detail with darker colours for refinement.

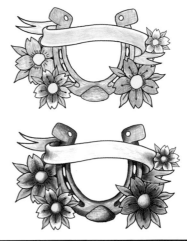

Step 7: Finally, add whichever words you'd like to the scroll, and a background colour if you wish.

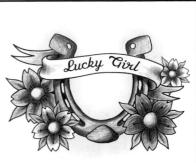

How to...
Draw a rose *by Jane Laurie*

Step 1: Find a picture of a rose. A symmetrical one will work best. Using tracing paper trace over your print-out of the rose with pencil, following all the inner and outer linework of the petals. Keep the lines simple.

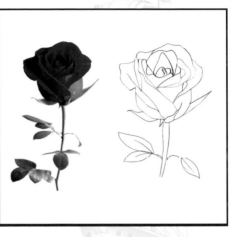

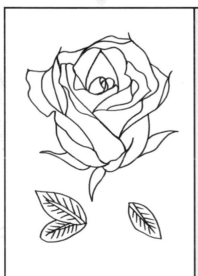

Step 2: Go over your lines with a black pen or ink. Make the lines bold. Simplify your rose if you wish – for example, in this picture, the stalk has been taken off and the leaves left separate. You can redraw these behind your rose if you wish, or cut them out and stick in place, and then scan the whole thing, or do the same thing digitally.

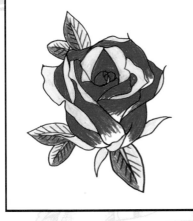

Step 3: Now colour in the rose with your desired colour, using paint, ink or coloured pencils. Keep your colours simple and flat for now.

Step 4: Pick out darker colours and shadows and refine the edges. Put a contrasting coloured circle behind the rose if you wish. Blue is used here to make the red really stand out.

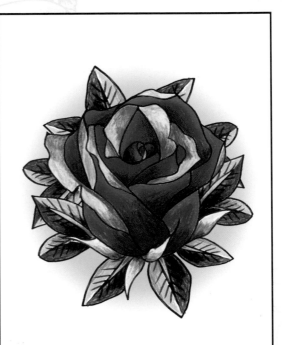

How to...
Draw wings *by Jane Laurie*

Step 1: Once you have found a wing shape you like, print it out. Place tracing paper over the top and trace around the edges of the wing with pencil. Draw around all the main feathers to get a feel of how they all sit on the wing shape. It is very easy to follow the outline of the feathers so long as you are using a good quality photo.

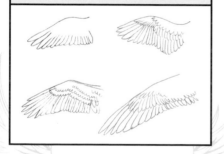

Step 2: If you want to have a really detailed drawing, you can refine all the details of each feather with your pencil. If you prefer to keep your wings minimal and bold, simply go over your existing lines with a black pen or ink.

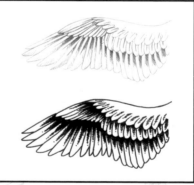

Step 3: Now you can colour your wings using any colour you wish. If you are creating angel wings, you will probably want to stick with white, but you can opt to keep the colour very simple – just add some highlights using a colour of your choice to the edges of the feathers.

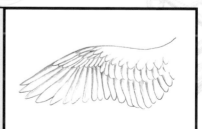

Step 4: If you want to be more creative, try using two contrasting colours for a vibrant effect.

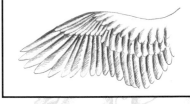

Step 5: If you want to create black wings, simply colour your wings in using black ink or coloured pencil, but remember to leave a white edge around all the feathers so that each of them can be seen.

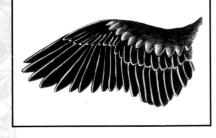

Step 6: If you want a pair of wings, use tracing paper to copy your wing the other way round. Then you can add some other elements to make it into a tattoo design.

Chapter 3
Classic tattoo art

In 1955 an exhibition in New York of Western tattoo flash marked a turning point in the popularity and widespread acceptance of tattoo designs as drawings of artistic value. So-called 'old skool' tattoos have a distinctive style, one that is instantly recognisable even to those not familiar with tattoo art.

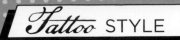

Symbols and designs

Old skool-style tattoos remain in high demand. A designer with a firm sense of the history of the art form understands the complexities of a design that at first glance appears to be simple. Looking at old-skool tattoo flash will provide inspiration for your own designs.

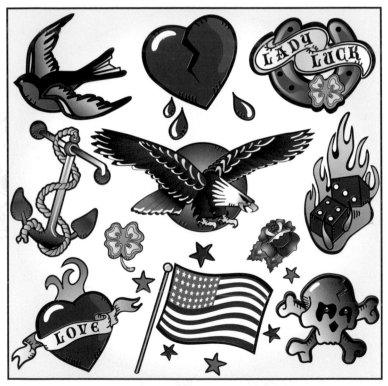

Some of the more popular elements of old skool tattoo design. Note the recurrence of certain motifs.

Glen Fontane, playing a US sailor in the Drury Lane Theatre production of *South Pacific* in 1951, paints a sailing ship 'tattoo' on the stomach of fellow cast member, Ray Walston, shortly before they go on stage, to emulate the tattoo designs worn by authentic sailors.

Clipper ship

Often popular with sailors, a clipper ship tattoo was frequently drawn with the words 'homeward bound' scribed below it. This type of tattoo was thought to act as an amulet to help ensure the sailor's safe return.

Sailor's cross

The Sailor's cross design is also known as the Rock of Ages. There are many ideas about what this popular design might have symbolised; perhaps it was a talsiman designed to protect the wearer. Another possibility was that putting a tattoo of a cross on your back – and by doing so signifying your Christian beliefs – was done in the hope that it could reduce the severity of a lashing given for disciplinary reasons.

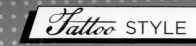
Anchor tattoos

Alone or incorporated into other designs, the anchor is a symbol that
conjures up thoughts of nautical themes as well as other branches of the
military. Its symbolic roots go back thousands of years, the most basic of
which being that the anchor, like the fish, was a symbol tied to the early
Christian faith. It represented a staunch and steadfast weight holding a
mighty ship securely in the harbour.

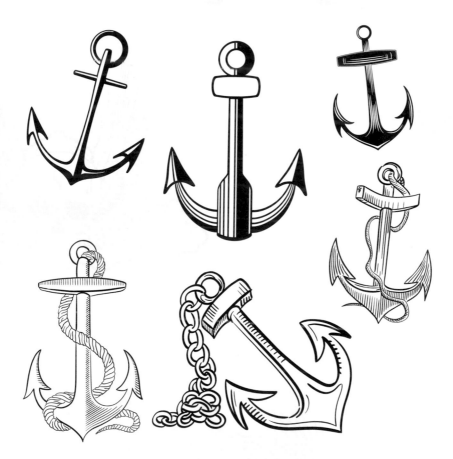

Sailor's grave

A macabre variation of the clipper ship tattoo – this time the ship would be shown as wrecked or submerged on an unsuccessful trip home.

Knives and daggers

Possibly the most common element in tattoo designs across all genres and eras, the knife or dagger could represent either military allegiance or religion with equal vigour. Representing a weapon for attack, a tool for survival or a symbol of commitment, few other elements exist in such a variety of designs.

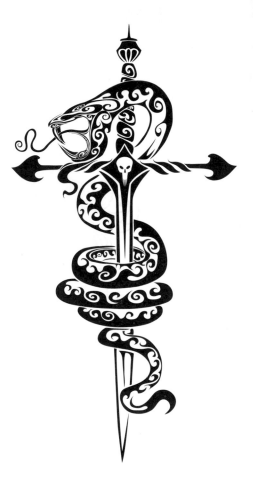

Allegiance tattoos

Symbols representing holidays and personal events are becoming increasingly popular, signifying an allegiance to groups or beliefs.

Flags

As symbols of patriotism, flags are immensely popular with servicemen and increasingly popular with the general population. They can be drawn in a realistic manner or heavily stylised – sometimes even in the shape of the home country itself. A popular symbol combines the elements of an American eagle with the US flag.

Military tattoos

In many ancient cultures warriors were identified with tattoo marks to indicate both their level of achievement and their 'rank' within the regiment.

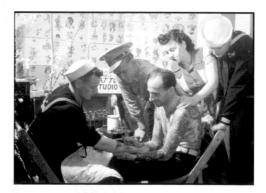

American sailors in a tattoo parlour, *c.*1940.

Cheesecakes

No, not the delicious pastries… 'Cheesecake' in this context refers to the image of a pin-up girl – derived from the days when someone would pull a photo or full-page illustration of a pretty girl out of a magazine and 'pin it up'. Pin-up girls as tattoos were particularly popular among sailors during the second World War. They would often have them placed on a bicep or even their stomach so that with some muscle movement they could make them 'dance'.

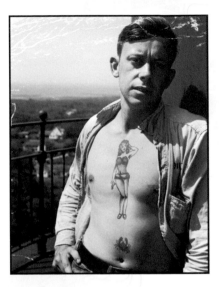

Big cats

Panthers, tigers and other large, dangerous cats continue to be very popular design choices. The leopard has long remained a symbol of power and grace in Asia and Africa, while the panther makes a powerful statement in other parts of the world, being perceived as a symbol of leadership, strength and courage.

Bluebirds and swallows

These are symbols of good luck in nautical circles. The bluebird is also thought to represent 'a man of laughter' in the Valentine's myth, symbolising happy love. Traditionally, a bluebird is tattooed on one side of a sailor's chest when he has travelled 10,000 miles at sea, and when he hits 20,000 miles he is allowed to put the bird's mate on the other side of his chest. Therefore, a chest adorned with twin happy birds gives the impression of a seasoned sailor. See page 126 for a basic how-to-draw-birds project.

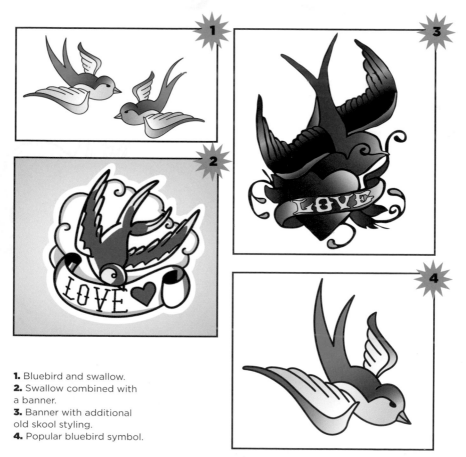

1. Bluebird and swallow.
2. Swallow combined with a banner.
3. Banner with additional old skool styling.
4. Popular bluebird symbol.

Cherries and cherry trees

On the tree it symbolises feminine chastity and purity; once plucked the cherry represents the loss of innocence and virtue. The blossoming of cherry trees is celebrated in many places around the globe, with festivals in China and Japan where the symbol is linked to the samurai class.

Dice

As well as often representing luck, a pair of dice
can also conjure up images of the dangers of
gambling and can sometimes be represented along
with other vices such as racehorses, drugs, alcohol
or *femmes fatales*. In addition, they can symbolise
a risk taker – someone who 'rolls the dice' to take
a chance.

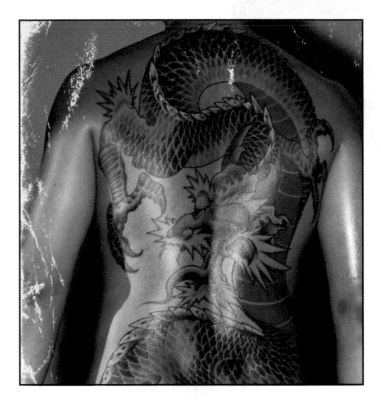

Dragons

These are one of the oldest and most classic tattoo elements. Every culture seems to embrace this mythical lizard-like creature, usually depicted with bats' wings and the ability to breathe fire.

A dragon is a popular choice among artists as well, since its intricate scaled body and veiny leathery wings present an interesting and dramatic illustrative challenge.

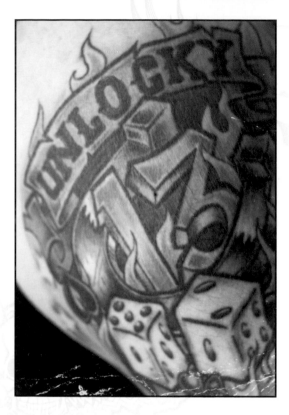

Man's vices

Gambling, drinking, drugs and wicked women are all elements which take a man off the course of the 'straight and narrow' and make this a popular subject for tattoo design. Elements comprising 'sinful behaviour' are often put together to illustrate the popular theme of man falling prey to his vices.

Horseshoes

One of the principle beliefs of tattoo wearers is that the designs serve as an amulet of sorts, so it's only natural that the horseshoe – a well-known symbol of luck – is often chosen as a permanent good-luck charm granting the owner its positive benefits.

Playing cards

Playing cards have long been a feature of tattoo designs – using the entire card itself or sometimes only smaller parts. Many of the cards denote their own meanings – the Ace of Spades, the Joker and the Queen of Hearts, for instance, can be understood the world over to stand for death, a prankster or the object of desire.

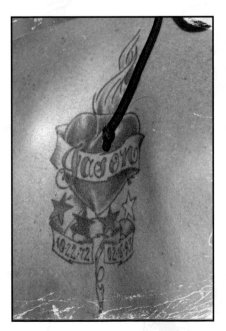

Memorial

Used as a way to remember or honour a loved one or friend, the stylised design of someone's name or initials lets the world know that they are not forgotten. The roots of this idea may well date back to the era of lost sailing ships.

Snakes

The snake appears in myths and legends in both
the East and the West and has carried its own
meanings and symbolism in different cultures
around the world. It may be a menacing symbol
or a symbol of protection.

Eagles

The eagle is an ancient symbol associated with the
sun and is especially popular in America due to its
staunchly patriotic connotations.

Hearts

A classic design and international symbol of romantic love that has been around since the first sailor had his heart broken in some far-off port of call. Often the name of a loved one is inscribed in a banner above, below or through the design of the heart; 'Mum' has always been a popular choice, especially for soldiers drafted into World War II and too young to have a steady sweetheart.

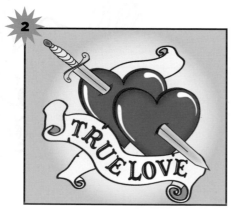

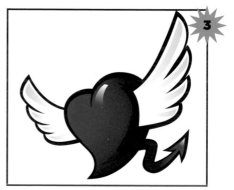

1. A broken heart that is patched together with roses, an arrow and fire speaks of conflicting emotions and a turbulent love: lust, sadness and true love are intertwined.
2. Traditional hearts with dagger and banner.
3. The angel/devil heart shows there are two sides to every lover and speaks of love and lust.

4

5

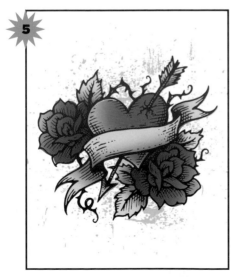

6

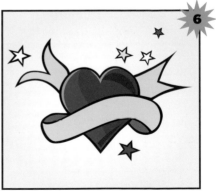

4. Biker/rock heart with banner.
5. Traditional heart with roses, banner
and arrow.
6. Young, starry-eyed heart with banner.

Don Juan *by Betsy Badwater*

Good old-skool traditional tattoo art tells a story using simple iconic images cleverly layered and boldly executed. This piece tells the story of a heartbreaker with blue roses (not found in nature) and three hearts pierced with a sabre. It could be worn down the forearm of the homewrecker himself or by one of his broken-hearted victims. What makes this piece old-skool traditional are the bold lines, the black shading and the classic rose style. Many artists develop their own rose formula.

Step 1: I started with the sabre and hearts because I knew they would be my foreground. When drawing old-skool traditional roses, it is essential at the start to establish the heart of the flower and the point of convergence for the alternating layered petals.

Step 2: Using different coloured pencils for the early sketching stages helped with decision making. Don't be afraid of an incorrect line, just keep drawing.

Step 3: I layered the sketched elements and started making decisions about which lines I wanted to keep. At this stage I could still continue making adjustments.

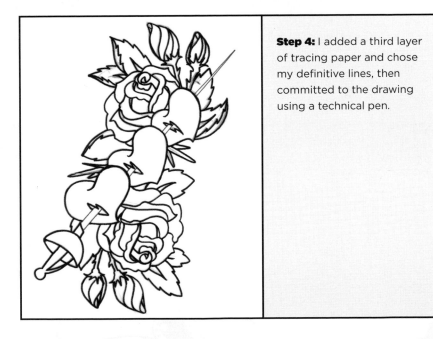

Step 4: I added a third layer of tracing paper and chose my definitive lines, then committed to the drawing using a technical pen.

Step 6: I outlined the foliage in green ink.

Step 5: To prevent the hearts disappearing into the bed of roses, and to add even more old-skool flair, I created a double contour line around the hearts and sword. I then transferred the sketch to watercolour paper and began inking using black India ink. Note that not all elements of tattoo art need to be lined in black.

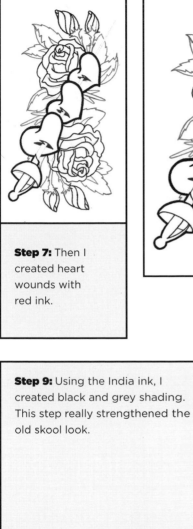

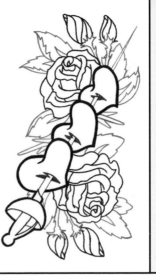

Step 8: I outlined the blade with blue ink, for emphasis.

Step 7: Then I created heart wounds with red ink.

Step 9: Using the India ink, I created black and grey shading. This step really strengthened the old skool look.

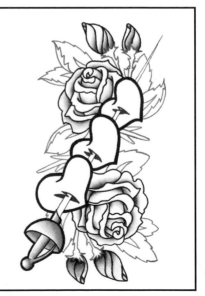

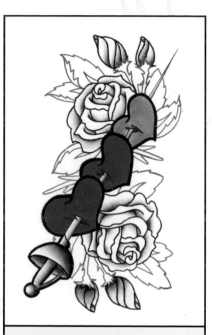

Step 10: I filled the hearts using one shade of red watered to three different tones. Having chosen a light source, I shaded the sabre handle with gold and then coloured the blade with blue.

Step 11: I added solid green to the foliage.

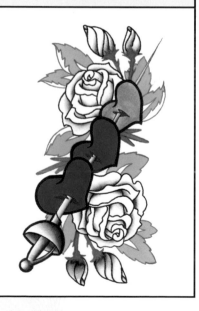

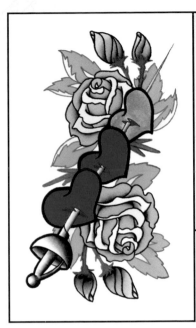

Step 12: With the darkest shade of blue I highlighted the rose centres, and then filled the folded petals with a lighter shade. Using yellow, I coloured the folds and spines of the leaves.

Step 13: To create an aged look and to simulate skintone, I added coffeewash.

The protector *by Betsy Badwater*

Custom design in tattoo art is tricky. To be successful, the design has to tell a cohesive story, even if the 'reader' doesn't know the inspiration. The protector tells a story of irony, love, desperation and loyalty. The protector is a hybrid fantasy serpent. She's part human, part cobra, part rattlesnake and quite alien. It may be shocking to find two darling little sleeping sparrows in the protector's coils, but their peaceful expressions indicate that they're right at home, even if you are frightened by their adoptive mother. In good tattoo art, the juxtaposition of elements and the use of conflicting visual statements can really work together to create one powerful piece.

Step 1: Once I had a concept, I gathered references. I wanted my hissing serpent to have a human skull, so I posed this skull I had lying around in what I thought was a good hissing position and asked a friend to snap a photo from my eye level. Then I printed it, and used it to create my skull sketch.

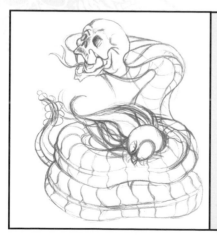

Step 2: I spent only about five minutes creating the first pencil sketch. The idea was to get the image out of my head and onto paper. I didn't care if it was not perfect; this was the planning stage.

Step 3: I taped down little bits of tracing paper and refined my ideas over the top of the original sketch. If I didn't like where I was going, I started all over again with a clear conscience as I had not wasted an entire sheet of paper.

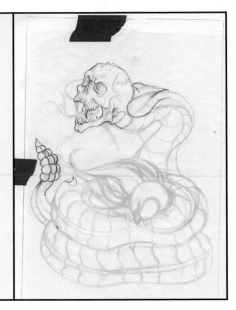

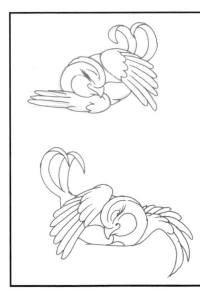

Step 4: I laboured over the nested bird. How could I demonstrate that the bird was at home and not threatened by the nasty monster I wanted to show protecting it? I decided to make the bird smile, give him big baby features, long eyelashes and snuggle him around the serpent's coils in a loving way.

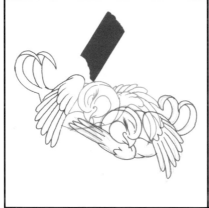

Step 5: One bird was a good idea, but what says comfort better than two baby sparrows nestled together? Two birds tell the story of comfort better than one. Therefore, halfway into my design, I changed my mind and added a second bird simply to make the story more readable.

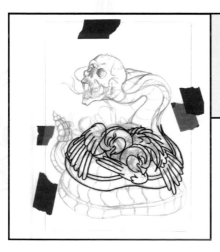

Step 6: I then put the various elements together.

Step 7: In the final sketch I fumbled with the tail placement. I therefore just marked my sketch with an 'X' where I didn't want a line.

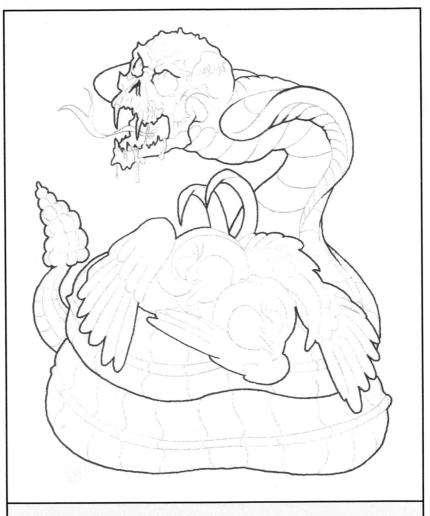

Step 8: I transferred the sketch to cold-pressed watercolour paper with graphite and inked a contour line only. I wanted the shading to do the hard work, not the lines.

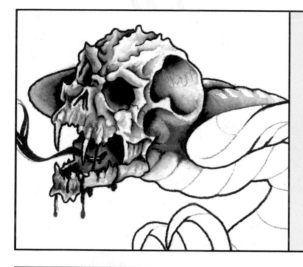

Step 9: I went straight to the head for the first shading pass. I chose my light source and used the shading to demonstrate the bony texture of my monster. The tar-black drool added extra menace.

Step 10: As I continued shading the body, I stayed true to the light source. I also studied a handful of coiled snake photos as reference for this stage of the painting.

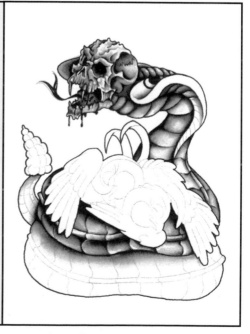

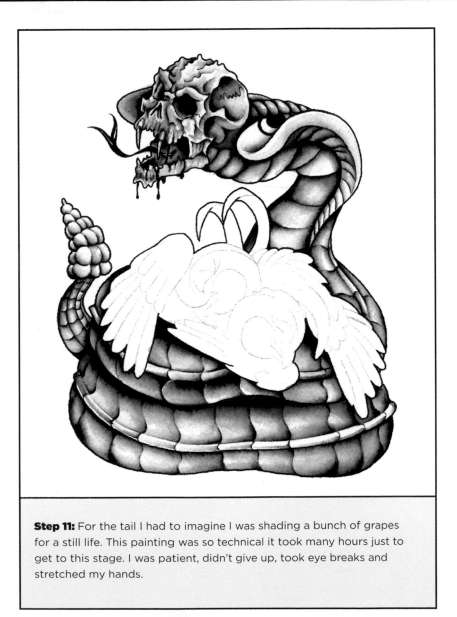

Step 11: For the tail I had to imagine I was shading a bunch of grapes for a still life. This painting was so technical it took many hours just to get to this stage. I was patient, didn't give up, took eye breaks and stretched my hands.

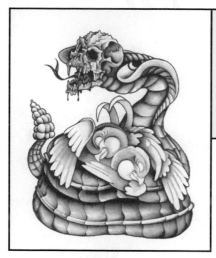

Step 12: I then added much softer grey shading to the sparrows. They're fluffy baby birds, and should highly contrast with the cold-blooded armoured monster.

Step 13: Mixing colour elements with black and grey can be disastrous, so I kept my colours very simple.

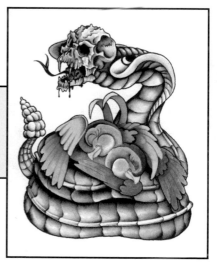

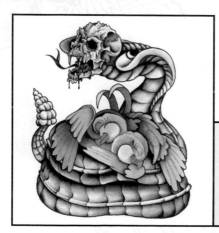

Step 14: Here's how the design looked when just simple black and grey.

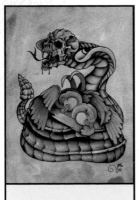

Step 15: You might choose to stop here, but I decided to take this a step further by using Photoshop to overlay a colour wash (in this case black and grey with coffeewash). You could also do this by hand.

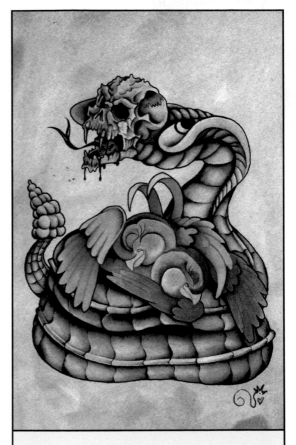

Step 16: I finally settled on black and grey plus a touch of colour washed with coffee.

Sailor's grave *by Allison Bamcat*

Combining the elements of symbolism, nautical design and memorial, the sailor's grave was popular among sailors to commemorate ships or friends lost at sea. Today, many modern artists follow this old skool-style symbol as a memorial design to remember a lost friend or relative.

Step 1: Using a Prismacolor blue pencil, I roughly sketched out my design. I then scanned in my image and added a line to the middle to create symmetry and moved some pieces of my image around in Photoshop. You could use tracing paper to do this.

Step 2: I printed my image out in order to clarify some of my pencil details, working to make things symmetrical.

Step 3: Once I was happy with my blue sketch, I made a photocopy of my image and traced over my lines with a regular graphite pencil to create a final line drawing.

Step 4: After this, I taped my pencil drawing to the back of a piece of Bristol paper. I then used a lightbox and a brush pen to create my final line drawing.

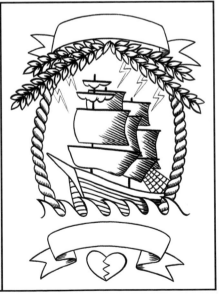

Step 5: Working to decide on my colour scheme, I scanned my linework into Photoshop and began to fill in flat colours. You could add colour by hand if you prefer.

Step 6: Using softer round brushes and the burn tool in Photoshop, I wanted to create depth in the elements of my design piece.

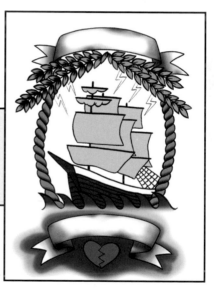

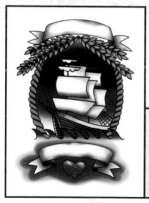

Step 7: I filled in the sky using darker violets to create a stormy scene, and I added more details to elements such as the heart.

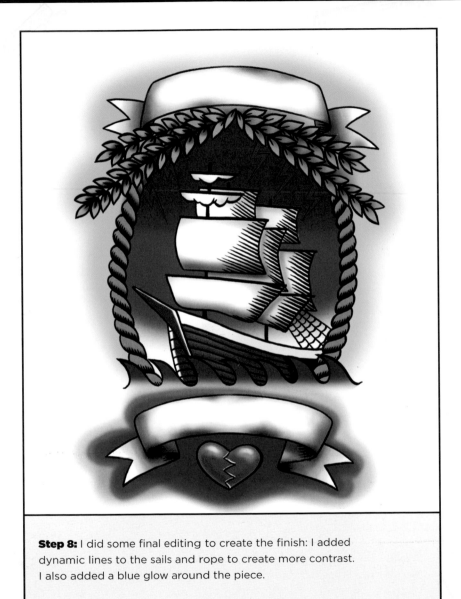

Step 8: I did some final editing to create the finish: I added dynamic lines to the sails and rope to create more contrast. I also added a blue glow around the piece.

Immaculate heart of Mary

by Betsy Badwater

Religious and spiritual iconography permeates tattoo art on a global level. For the sake of demonstration, the Immaculate heart of Mary is an appropriate piece to demonstrate old-skool light effects, the power of repeating elements and the interpretive flexibility in communicating iconic elements in good tattoo art.

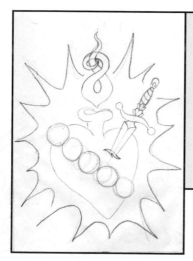

Step 1: As the Immaculate heart of Mary traditionally includes a heart bound with five roses, a cross, a piercing element, light and fire, I imagined the fire and the cross as one element to simplify the design. It would also give an interesting flow to the fire and oppose the light burst linearly.

Step 2: I then practised ideas for the dagger handle and the tiny roses.

Step 3: Once I had decided on the rose shape, I traced identical roses on the heart, alternating the positions slightly, and layering some of the petals. I then added tears.

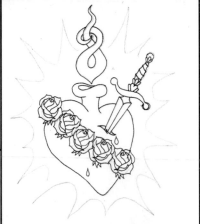

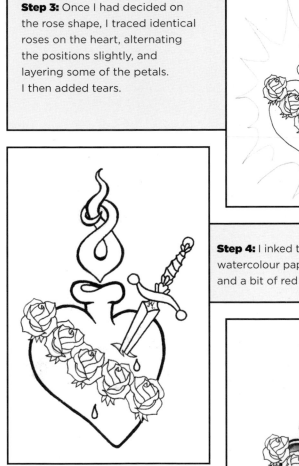

Step 4: I inked the design on watercolour paper with black and a bit of red ink.

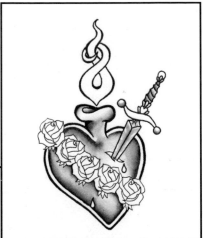

Step 5: I then added black and grey shading using waterproof ink.

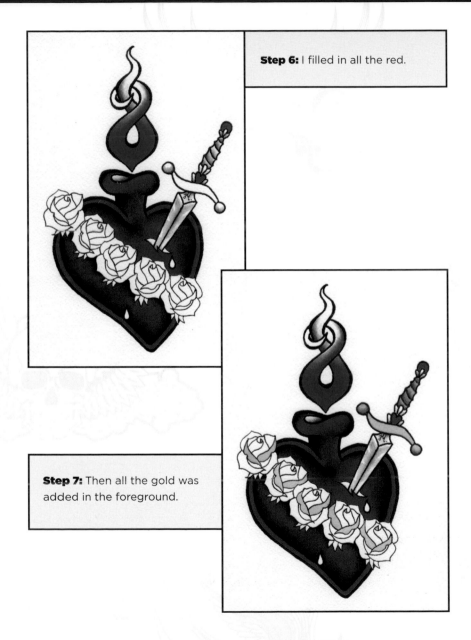

Step 6: I filled in all the red.

Step 7: Then all the gold was added in the foreground.

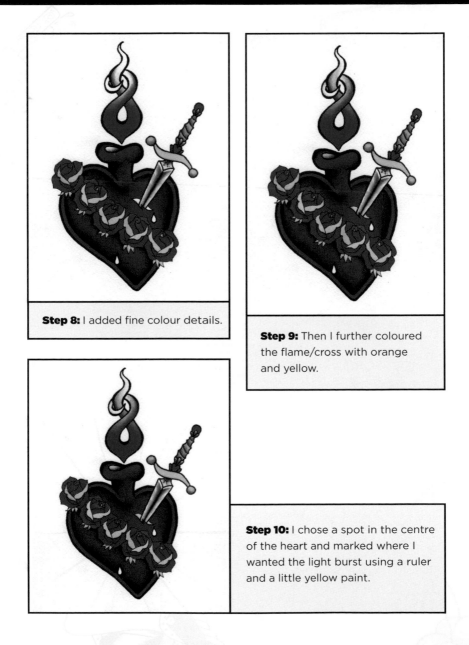

Step 8: I added fine colour details.

Step 9: Then I further coloured the flame/cross with orange and yellow.

Step 10: I chose a spot in the centre of the heart and marked where I wanted the light burst using a ruler and a little yellow paint.

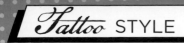

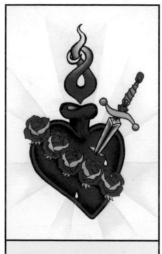

Step 11: I filled in the light burst with bright yellow.

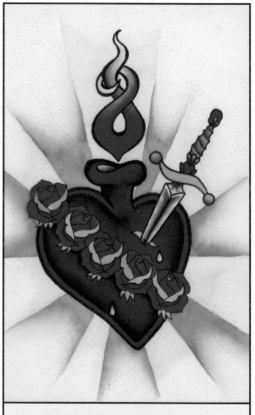

Step 12: To create radiance, I added orange between the yellow bursts.

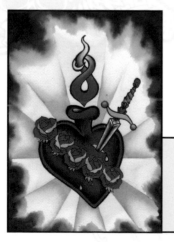

Step 13: For a celestial touch, to give depth and to intensify the brilliance of the light burst, I added blue clouds at the edges.

Step 14: Finally, I used a quick and messy coffeewash to age the piece and intensify the colours.

Old skool swallow
by Jane Laurie

Find a picture that you like of a bird flying. For this example, a swallow is used. Swallows are classic tattoo birds, used in the past by sailors to show how many miles they had sailed over the world. One bird tattooed on one side of the chest represented 10,000 miles, and once the sailor had sailed 20,000 miles, the birds' mate was tattooed on the other side.

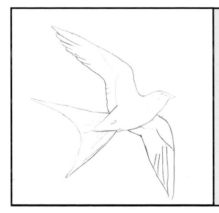

Step 1: Using tracing paper, draw around the outline simply with pencil. Mark a few of the inner details such as feathers, feet and any specific markings the bird might have.

Step 2: Now go over the outline with black pen or ink, making the lines bold and keeping the shapes simple.

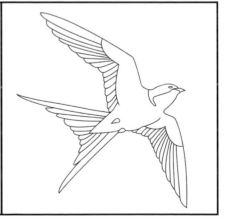

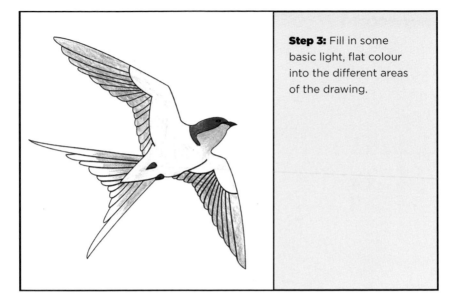

Step 3: Fill in some basic light, flat colour into the different areas of the drawing.

Step 4: Finally, fill in shading details such as shadows and darker/brighter areas of colour to really make the drawing 'pop'.

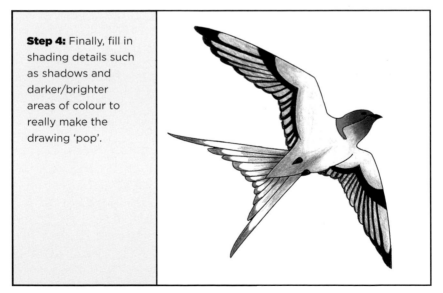

Mermaid *by Molly Crabapple*

Molly Crabapple is an artist for the *New York Times*, *Wall Street Journal*, Marvel Comics and DC Comics, and has illustrated more than a dozen books. She's also turned her talents to giant theatrical backdrops, parade installations, burlesque posters and gallery shows around the world. The mermaid is a timeless and popular image, often chosen by both sexes as a tattoo design and placed in varying sizes all over the body.

Step 1: I started with a rough pencil outline indicating the gesture of the body and the major features. I worked especially hard on making a nice gesture for the mermaid's tail.

Step 2: Then I tightened the pencil outline and made sure to include all the details.

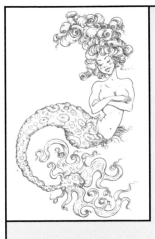

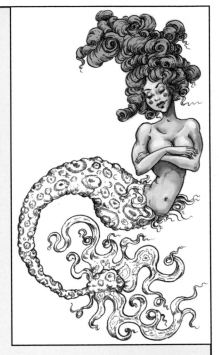

Step 3: I started inking, using Higgins Black Magic ink and a #1951 Francois Gillott pen nib. I worked at creating interesting patterns on the mermaid's scales and hair.

Step 4: Once I had finished, I scanned the ink drawing. To remove any remaining pencil lines, in Photoshop I selected 'Levels' and used the white eyedropper to select the whites, then the black eyedropper to select the blacks. (You could simply erase the pencil lines if you are working by hand.) I then selected all, cut and pasted the ink drawing onto a new layer, and then set that layer to 'Multiply'. I adjusted the lightness and colour balance so the line became purple. I made two layers, entitled 'Hair' and 'Skin'. Using a fairly broad brush, I laid in flat colours for each of these, each on their own layer, then started adding in darks and lights with the airbrush.

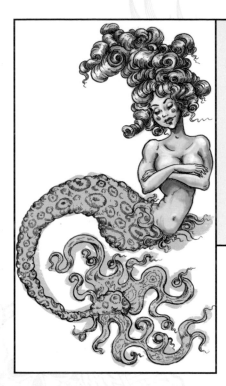

Step 5: I laid in a flat green for the tail and, using a dry brush, created some hard highlights for the hair.

Step 6: With the eraser brush I deleted the green that had gone outside the lines. Using dry brushes with yellow, white and salmon, I brought out the pattern of the scales and made sure my strokes were decorative.

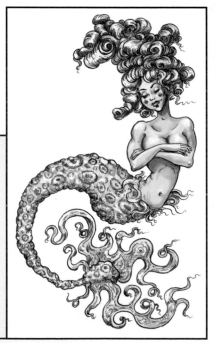

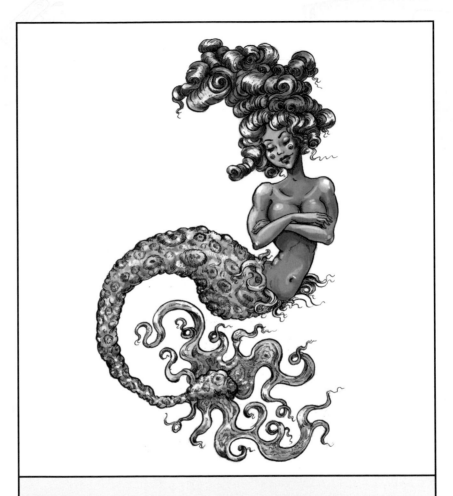

Step 7: Over the entire drawing, I made a multiply layer called 'Glaze'. I flood-filled the drawing with magenta, and turned the transparency down to around 20%. I erased all magenta that was not on my mermaid, and used a fairly transparent airbrush to erase parts of her figure and make them 'pop'. Finally I used a dry brush to carve more highlights in her hair and put sparkling bits on her tail.

Reverse mermaid *by Molly Crabapple*

I conceived reverse mermaids as a classical mermaid's ugly yet practical sisters. This is a back piece, so I wanted something symmetrical that filled a lot of space.

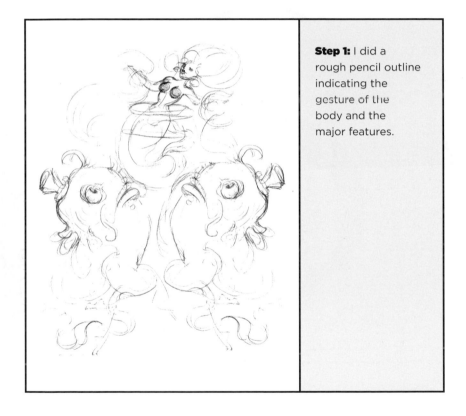

Step 1: I did a rough pencil outline indicating the gesture of the body and the major features.

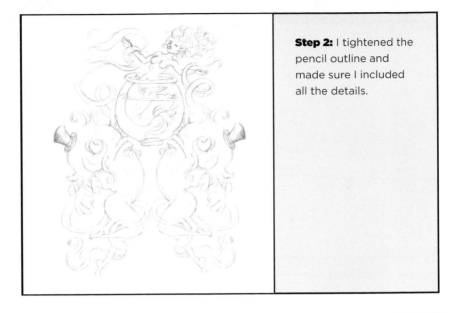

Step 2: I tightened the pencil outline and made sure I included all the details.

Step 3: I started inking, using Higgins Black Magic ink and a #1951 Francois Gillott pen nib. I went for abstract patterning in the scales, and flow in the ribbons.

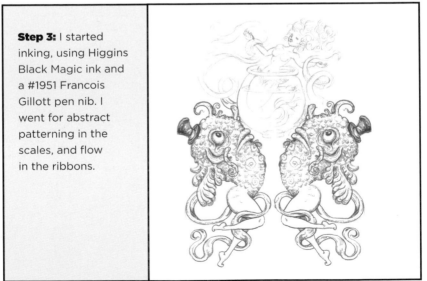

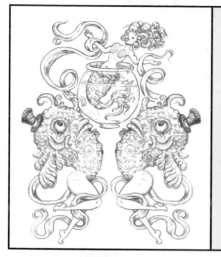

Step 4: I scanned the ink drawing. Using Photoshop I removed any remaining pencil lines. (You could simply use an eraser if you are working by hand.) I selected all, cut and pasted the ink drawing onto a new layer and then set that layer to 'Multiply'. I then adjusted the lightness and colour balance so the line became brown. I made three layers, entitled 'Skin', 'Hair' and 'Scales'.

Step 5: Using a fairly broad brush, lay in the base colours.

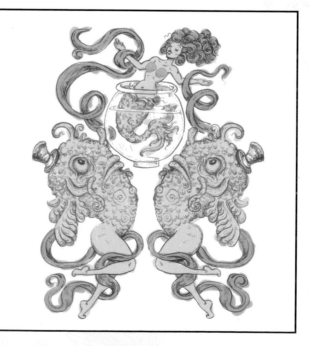

Step 6: I laid in darks on multiply layers, and lights, each on their own layer. Over the entire drawing, I made a multiply layer called 'Glaze' and flood-filled the drawing with magenta. I then reduced the transparency to around 20%.

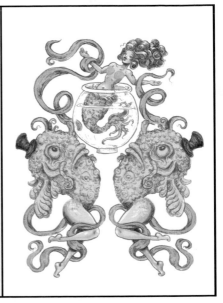

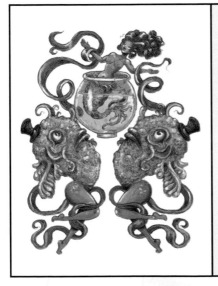

Step 7: I erased all magenta that was not on my mermaid, and used a fairly transparent airbrush to erase parts of the figures and make them 'pop'. I used a dry brush to carve more highlights into the hair, then used a pale yellow brush that looks like charcoal to make the scales glisten and carve a hard highlight on the fishbowl.

Pirate girl *by Molly Crabapple*

Here Molly Crabapple explains how she went about creating her
tattoo design, pirate girl, using magic ink.

Step 1: My pirate girl is meant for
a shoulder tattoo, so I gave her a
rounded shape to sit nicely on a
bicep. I did a rough pencil outline
indicating the gesture of the
body and the major features.

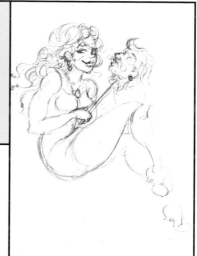

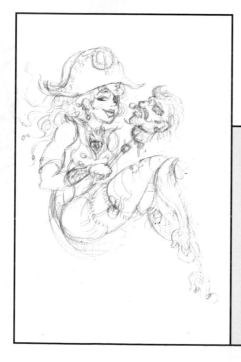

Step 2: I tightened the pencil
outline and made sure to
include all the details. I also
gave her a jaunty hat.

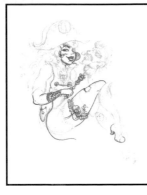

Step 3: I started inking, using Higgins Black Magic ink and a #1951 Francois Gillott pen nib.

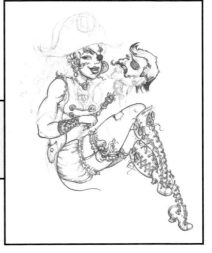

Step 4: I added more detail. And laces – many, many laces.

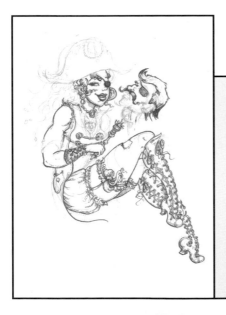

Step 5: When finished, I scanned the ink drawing into Photoshop – to remove any remaining pencil lines I went to Image> Adjustments> Levels. I selected the pencil lines with the white eyedropper – which wipes them out. Then I selected the darkest black with the black eyedropper which intensifies the blacks. You could achieve a similar effect by simply erasing your pencil lines and boosting the ink lines.

Step 6: Using the magic wand, I selected one of the black lines then went to Select> Similar to grab all the black lines. Next, I went to Image> Adjustments> Hue/ saturation. On the right of the hue box I checked 'Colourise' then, using the hue saturation and lightness bars, I adjusted them until the black lines of the drawing were a shade of purple. I clicked 'OK'. On my Layers palette I added a new layer which I changed from normal to multiply and titled it 'Skin'. Using a fairly broad brush I laid flat colours over the skin areas. I added another

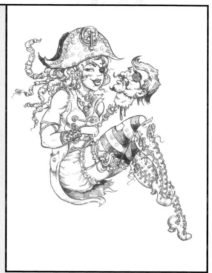

multiply layer which I called 'Dark', where I added in dark shades with a finer airbrush. Note, I made the gentleman greenish to highlight his decomposing state.

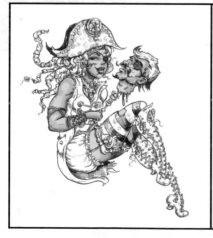

Step 7: I laid in base colours, darks on multiply layers and lights, each on their own layer. I then made a layer titled 'extreme highlights', put it on top of the other layers and carved out some harsh whites. I also used it to clean up anywhere I'd coloured outside the lines.

Step 8: Over the entire drawing, I made a multiply layer called 'Glaze'. I then flood-filled the drawing with magenta, and turned the transparency down to around 20%. After that I erased all magenta that was not on the mermaid, and used a fairly transparent airbrush to erase parts of her figure and make them 'pop'. I used a dry brush to carve more highlights into her hair.

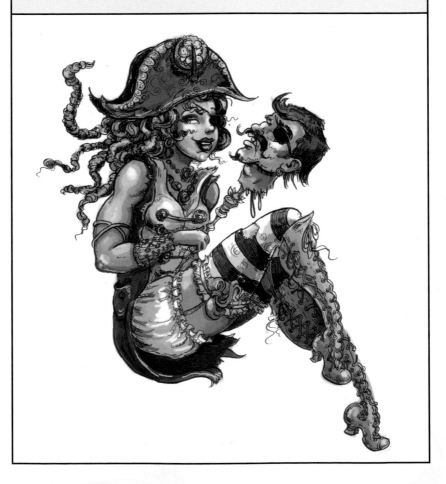

Chapter 4

Japanese-style tattoo design

Tattoos have undergone vast changes in the Japanese culture. At times they have been a badge of honour, or a symbol of power or solidarity, and at other times they have been viewed as distasteful or even criminal.

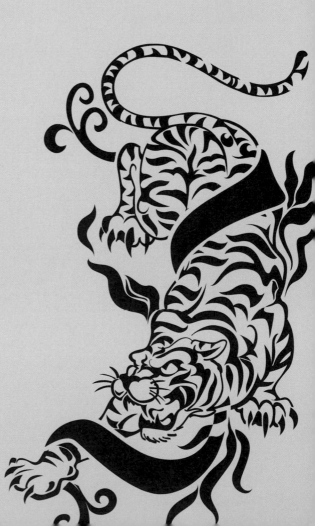

The language of *irezumi*

The traditional images of *irezumi* (traditional Japanese tattooing) have innumerable meanings and subtexts. Many are taken from old texts such as the famed *Tale of Genji*, Buddhist and Shinto mythology, the Chinese novel *Suikoden* or the natural world. To understand the meaning behind *irezumi*, you should investigate the legends and literature that inspired this art form.

Flora and fauna

Flowers such as the chrysanthemum, peony and lotus are revered; these symbols, associated with holiness, have been worn by emperors and priests for centuries. Crashing waves, violent wind and swirling clouds represent the ultimate power of nature – beautiful but terrible. Animals such as the koi, snake, tiger, dragon and rabbit each have their own meaning (different from those in the Chinese zodiac).

Cherry blossom

The sometimes-controversial cherry blossom (*sakura*) is a common *irezumi* image. Cherry blossom is a national Japanese treasure, representing humans' brief but joyful time on Earth. During the second World War, the image was reappropriated for kamikaze pilots whose planes fell from the sky like the blossoms dying. It can sometimes represent militant politics, but more often is a symbol of the coming of spring.

The rabbit

The rabbit implies the sexuality of women. One minute lovely and cute, but underneath showing surprising ferocity.

The snake

The snake may seem like a creature to be feared, but according to legend it is the quiet messenger of God.

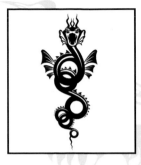

The koi

The koi, or carp, is a fixture of Japanese tattooing and features in both Chinese and Japanese fables. As a symbol it represents strength of character and purposefulness.

The Tengu

The Tengu, or evil spirit, is one of the most well-known myths. This playful but mean-spirited demon has a bright red face and a long nose, and it shrieks and jumps through the trees at night.

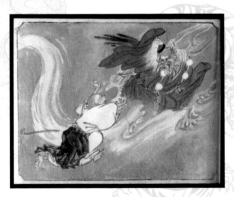

The Ki-rin

The Ki-rin is a holy beast of prosperity. Ki, from the character for gold, brings extraordinary luck to whoever sees it. Such a sight, however, would be a horrifying spectacle, since the Ki-rin posesses the limbs of a horse, the tail of an ox and the face of a wolf. It is said to live 2,000 years.

The Hou-ou

The Hou-ou, or phoenix, is the eternal deity of peace. It rises from its own fiery ashes every 500 years, and lives only on the seeds of bamboo.

Dragon tattoos

Dragon tattoos are heavily influenced by Japanese and Chinese culture, where the dragon represents the four elements and the four points of the compass. Dragons symbolise nobility, magic, the power of transformation and imagination, perseverance and power.

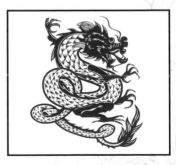

Kanji

Kanji are Japanese characters appropriated from their original Chinese origins. In the fourth century, when Chinese traders were roaming over what would become Japan, language and artistic ideas were shared and combined, ultimately to divide into their own separate languages and cultural voices.

chikara (power)

ai (love)

ten (heaven)

haha (mother)

eien (eternity)

a-ni (older brother)

imouto (younger sister)

a-ne (older sister)

chichi (father)

otouto (younger brother)

kibou (hope)

Japanese-style tattoo *by Veronica Hebard*

Veronica was educated at the School of Visual Arts, in New York, and the
Massachusetts College of Art in Boston. She has designed tattoos for a variety
of clients all over the world. Her *irezumi* tattoo design is a feminine, yet
powerful, design which would particularly look good drawn large and placed
on the back. It is strongly influenced by Japanese linework.

Step 1: I started by sketching the body of the
tiger, since it was the anchor for the whole piece.
I knew I wanted to keep it feeling 'in motion', so
the spine of the animal would twist and make a
kind of S-shape. I wanted it to look as if it were
crawling on someone's skin!

Step 2: I sketched the woman's body with
her back a bit curved, keeping the motion of
the design. You won't see her hands, as she
will wear a long-sleeved kimono, called a
furisode. I made her look a bit coy by not
quite covering her face.

Step 3: The peonies went in next; I started
by drawing the bud in the centre and adding
petals around in a circle. Peonies are like huge
roses, and I exaggerated these further, as a
design element.

Step 4: Another peony went in; this gave the composition balance. Also, if the client decided to continue their tattoo, the peony would be like a 'cushion' between other potential elements.

Step 5: I then refined the tiger's head. Using Japanese art books as reference, I carefully made his face look similar to *ukiyo-e* prints. It was a bit cartoon-y!

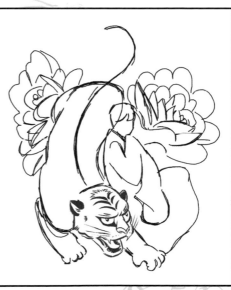

Step 6: Then I refined the woman's kimono. Kimonos have lots of layers underneath, so I had bits of cloth visible. But these also looked cool as geometric lines, and gave the fabric good shape and movement!

Step 7: The peonies were finished next, giving their petals ragged and curling edges. This provided a nice contrast to the smooth lines of the kimono.

Step 8: I then went back to the tiger's body, smoothing out his overall shape, and adding in some bits of fur texture. His paws were made a little on the cartoon-ish side, to reference more antique woodblock prints of Japan.

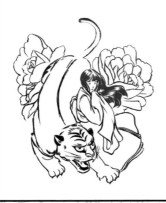

Step 9: I then tackled the woman's face. Looking at *ukiyo-e* prints again, I drew her face to match an old-world style, with high, short eyebrows and a small, pouted mouth.

Step 10: The stripes were last. I slowly made them, spacing them evenly around the tiger's muscles. They seemed to drip down like black ink.

Step 11: Finally, in Photoshop, using a layer above the final drawing and setting the layer to 'multiply', I coloured the piece in the same traditional Japanese style, almost like watercolour, blending from the outer edges in. This also gave the flowers a cool glowing effect. You could use real watercolour if you prefer.

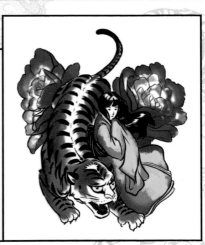

Japanese cat *by Allison Bamcat*

Allison Bamcat is a freelance illustrator, currently located in Boston. Originally from Los Angeles, Bamcat moved northeast and earned a bachelor's degree in Illustration at the Massachusetts College of Art and Design. Her lucky cat ghost is a well-balanced design which would transfer well to different parts of the body. It is not predominantly masculine or feminine.

Step 1: To make something slightly bizarre while staying with an Asian- and classic tattoo-inspired theme, I used a lucky cat as a ghost. Beginning with blue lead in a mechanical pencil, I sketched out my larger shapes and slowly worked in smaller details (like a belly-button).

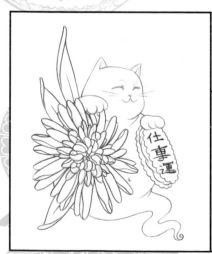

Step 2: Next, using regular lead, I finalised my sketch lines and created better depth in the petals of the flower, curling some of the edges to make them 'pop' more. I also fixed the characters on the cookie.

Step 3: Happy with my final sketch, I made a photocopy of it, larger than the original, to trace on a lightbox. I traced the main cat in black, but I traced the flower, cookie creme and eyebrows with orange pencil lead instead.

Step 4: I then began to fill in my shapes, starting with the darkest colours and working my way up to the highlights, layer by layer of dry-brushing. It was slow, but the depth it created is worth it. I also decided to give the cat a big white belly.

Step 5: After all of my shapes were painted to completion, I used black Deleter ink to outline the cat with a small brush. I also used metallic ink for the Chinese characters on the cookie.

Modern Japanese tattoo *by Edwin Ayala*

Edwin is an illustrator from Everett, Massachusetts, and a current apprentice at Ferry Street Ink. When he is not drawing new illustrations he is creating new tattoo designs or getting new tattoos. Edwin is on the long and adventurous journey to achieving his dream of becoming a tattoo illustration artist. Edwin's Oni design is modern and funky. It would transfer well to various parts of the body and is not typically masculine or feminine.

Step 1: As is my habit, I started this tattoo design in my sketchbook, playing around with what worked and doing all my problem solving before I took the design through Photoshop. When I was satisfied with my sketch I went over it with tracing paper and imported the basic outline into Photoshop.

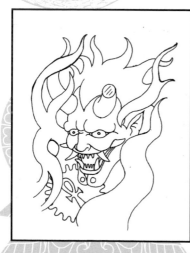

Step 2: Outline and colour stage. Once I had the outline all figured out I started overlaying the colours, starting with a light mid-tone colour on the face.

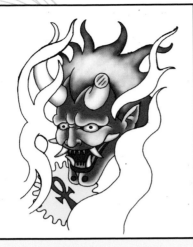

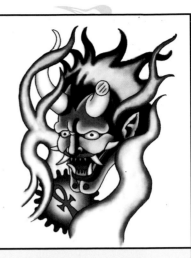

Step 3: Once the mid-tones were complete, I added more dark tones and more colour to the smoke around the face.

Step 4: Once I had a set idea on all the colours I added all the darker tones to make the face of the Oni pop out more. Then I coloured in much of the smoke, giving the edges an eye-catching outline.

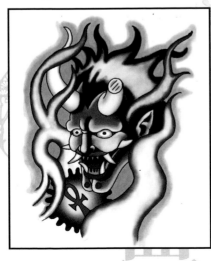

Step 5: Finally I added some colour around the smoke and face to give a classic feel to the tattoo.

Chapter 5

Tribal-style tattoo design

To the tribal tattoo designer, what the tattoo means is even more important than its appearance. It's about making a statement; aligning yourself with a group or a set of ideals. Tribal tattoo design tends to make heavy use of blocks of ink and line art.

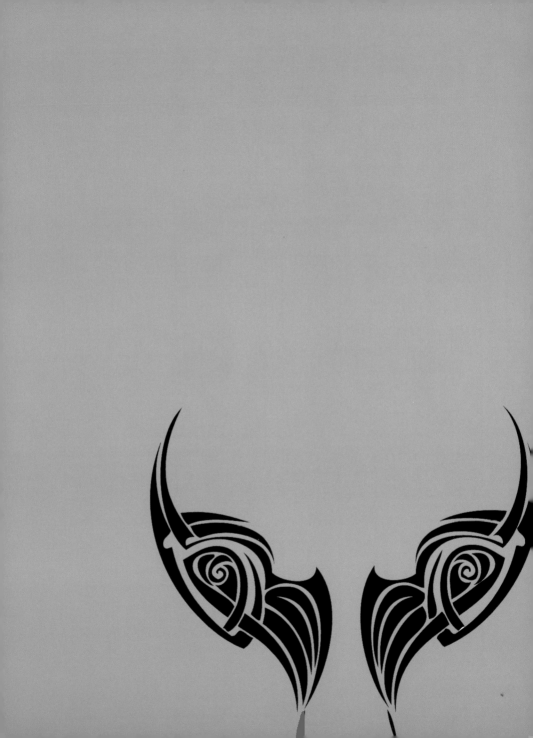

Samoan tribal tattoo
by Veronica Hebard

The circular symbolism of this design represents infinity. The serpent biting its own tail indicates a creature literally eating itself, symbolising the cyclical nature of the universe and all life within it – destructive yet linked with renewal. Serpents and serpent imagery are popular as a motif in tribal tattoo designs from different cultures.

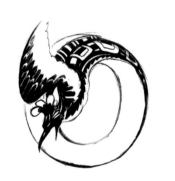

Step 1: I decided on a central image for this tattoo. I wanted it to be round and fit nicely on a client's shoulder, so I settled on Quetzalcoatl, a Mayan half-bird/ half-snake legend.

Step 2: Tribal tattoos are often only one or two colours, so I assumed this one would be just black ink and made lots of graphic shapes along the bird wing and snake's back. Looking at South American art books, I tried to make the geometric shapes look similar to old stone carvings.

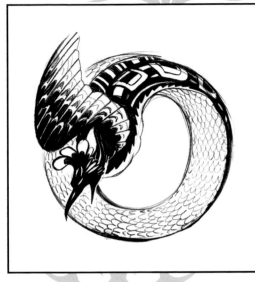

Step 3: I added lots and lots of tedious but lovely scales and wing details to the image.

Step 4: I began a kind of Aztec face on the bottom, making its form echo the round of the bird/snake. I wanted this image to be very symmetrical, so I only did half the face with the intention of making a copy and flipping it digitally.

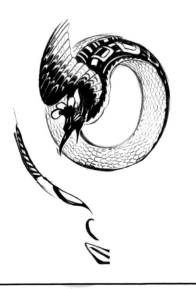

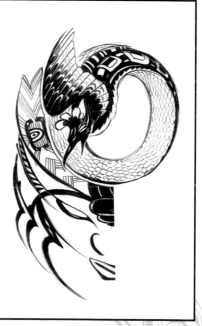

Step 5: A lot of tribal tattoos have sharp edges, so I made some sharp images curve around the face. These were also dynamic lines to adorn the wearer's arm.

Step 6: I added another geometric element to the headdress. I made the centre image similar to the Mayan numeric writing system of dots and lines.

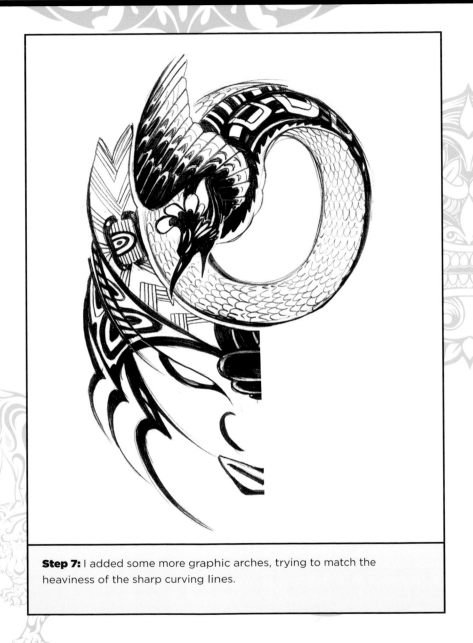

Step 7: I added some more graphic arches, trying to match the heaviness of the sharp curving lines.

Step 8: I scanned the drawing into Photoshop. I copied the face, then pasted and reflected the image. You could also use the tracing paper method used on pages 68–69.

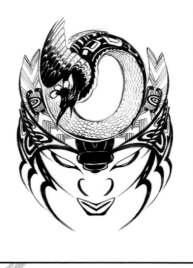

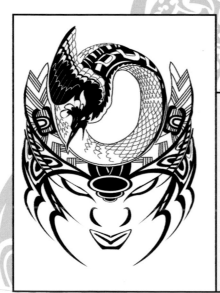

Step 9: I cleaned up the image digitally in Illustrator. I literally traced over everything drawn with the pen tool; it was a long process but necessary to achieve a finished image.

Step 10: Once the image was vectored, I brought it back into Photoshop for a few more tweaks. I cleaned up the edge where the bird wing met the snake, added some dots to the bird feathers and otherwise perfected it as best I could.

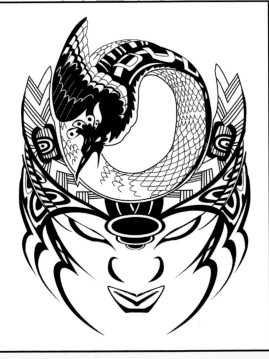

Step 11: I did a quick colour treatment in Photoshop to see how a maroon gradient would help the image. It was then ready to be sent to a tattoo artist for inking!

Tribal heart *by Jane Laurie*

Step 1: I drew a rounded heart shape in pencil.

Step 2: I divided the illustration in half – from now on I only needed to work on one side, and then could reflect the finished design to make sure it was symmetrical.

Step 3: I began to add tribal patterns to the outline heart shape.

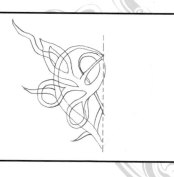

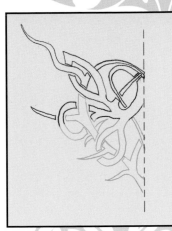

Step 4: Once I was happy with the patterns I had added, I traced over the lines in soft pencil. I needed to show how the lines overlapped each other and intertwined by stopping some short where they crossed.

Step 5: I flipped the tracing paper over and went over the areas where I had traced to transfer the pencil markings to the paper.

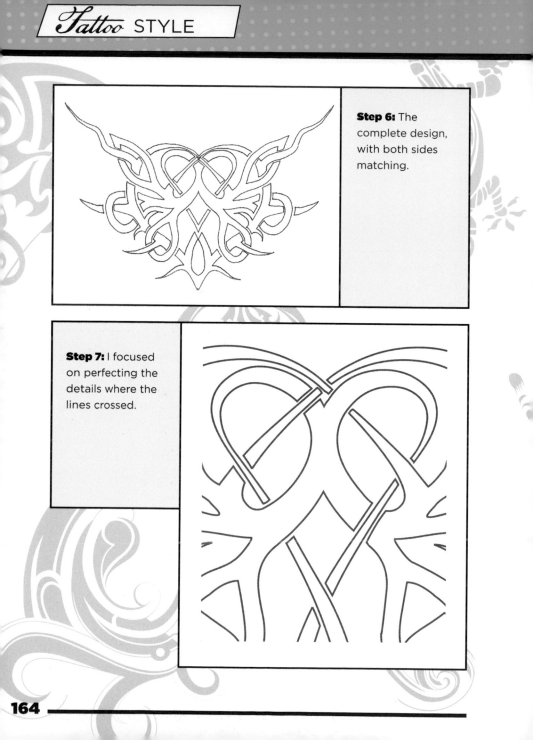

Step 6: The complete design, with both sides matching.

Step 7: I focused on perfecting the details where the lines crossed.

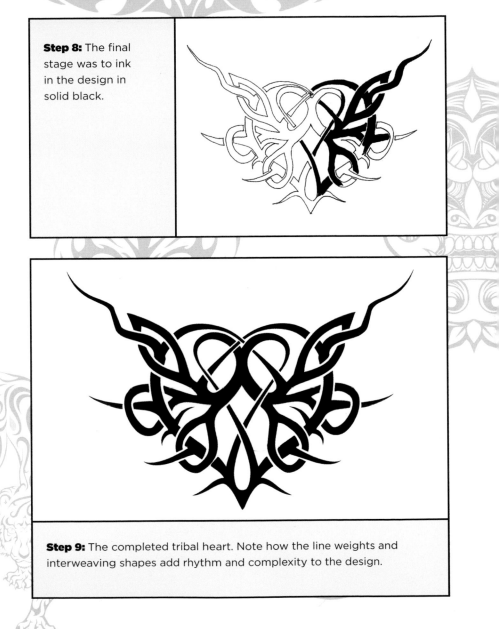

Step 8: The final stage was to ink in the design in solid black.

Step 9: The completed tribal heart. Note how the line weights and interweaving shapes add rhythm and complexity to the design.

Celtic cross *by Jane Laurie*

Step 1: I drew a cross shape in pencil.

Step 2: I formed the Celtic shape of the cross by thickening the bars and flaring them towards the ends and drawing a circular outline behind them.

Step 3: I turned the design into a thicker outlined shape.

Step 4: I experimented with different Celtic-style interlocking designs with which to fill the cross outline.

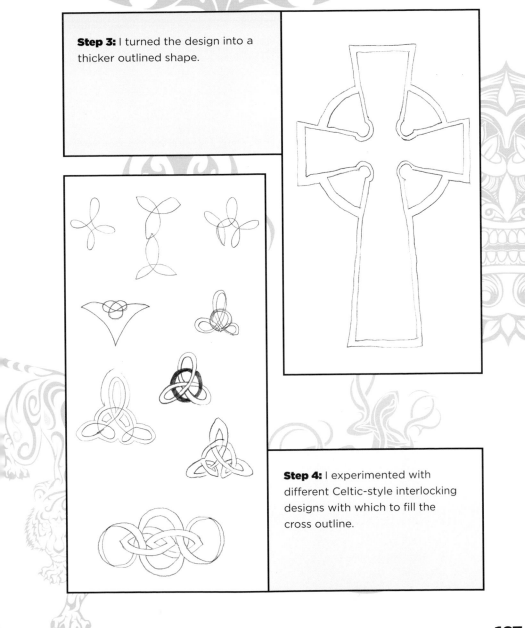

Step 5: I sketched in the fillings for the cross outline. I started with the basic lines.

Step 6: I worked up the lines, concentrating on making them the correct thicknesses and working out how they were to interlock on the finished design.

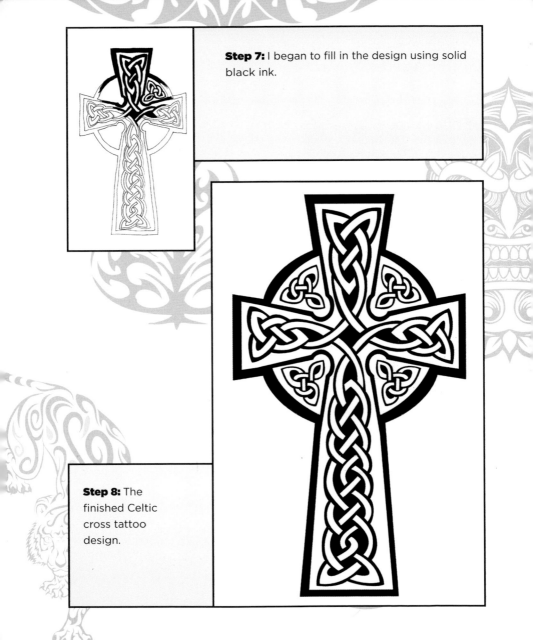

Step 7: I began to fill in the design using solid black ink.

Step 8: The finished Celtic cross tattoo design.

Chapter 6
The macabre

Death and horror imagery are recurring motifs in tattoo design. They can also be given a comic treatment for a more modern take on the genre. The juxtapositions of skull and mermaid and clown and demon in this chapter are fine examples of the modern trend for mixing tattoo genres.

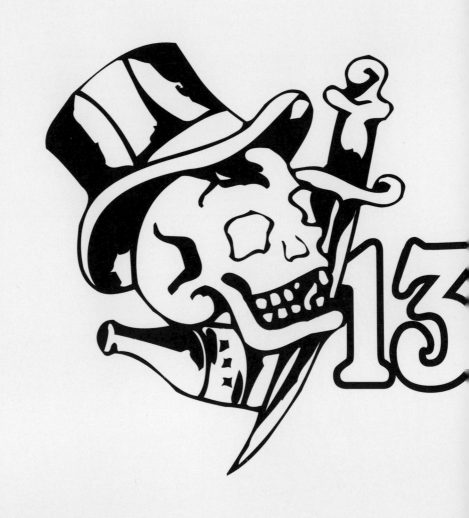

Grim reminder *by Mister Reusch*

This design incorporates the typical representative for death in his long black cloak, and is a grim reminder of mortality and the transience of life. A striking tattoo design, this will remind its wearer at all times of the motto *carpe diem*.

Step 1: I started out using pencil in my sketchbook, showing a winged, hooded Grim Reaper beckoning with one hand and holding an hourglass in the other. All the sand in the hourglass was in the bottom part, thereby signifying that time was up.

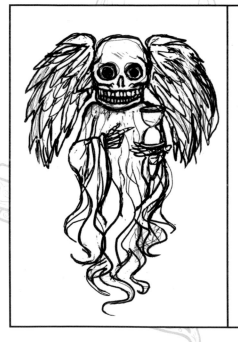

Step 2: I scanned the pencil sketch into Photoshop, increased the brightness and contrast and used the brush tool for my dark lines. (You could simply use a brush and ink and erase your pencil lines.) I changed my concept, thinking a more benevolent Reaper pointing at an hourglass with some sand left in the top part would be a good reminder to make the most of life. I therefore removed the hood, and shortened the wings and attached them to the Reaper's head the way they're seen on old gravestones.

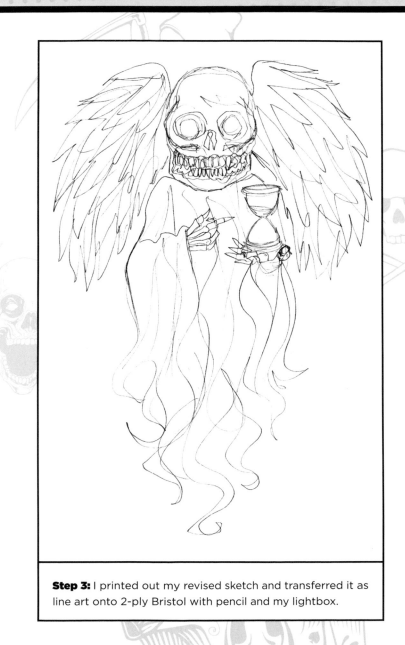

Step 3: I printed out my revised sketch and transferred it as line art onto 2-ply Bristol with pencil and my lightbox.

Step 4: I inked in my pencil lines using a Prismacolor premier chisel-tip marker, then used diluted Black Magic India ink to paint dark values on the Reaper's skull and hands. Once the ink was dry, I painted the whites in with undiluted white gouache to create the texture I wanted.

Step 5: I scanned the final inked art into Photoshop, heightened the brightness and contrast, created a new layer in the 'multiply' mode, and began adding colour with two or three different brushes.

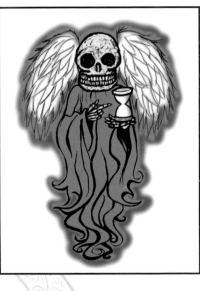

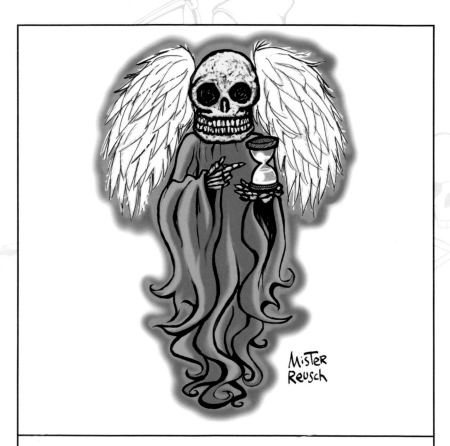

Step 6: I coloured the final product in Photoshop using a few different brush tools in two layers. (You could simply colour an inked drawing.) Throughout this process I continually refined the Reaper's robes, simplifying the lines and folds.

If the image I'm working on is a freelance assignment and the client has approved a final sketch, I make sure the final art is true to the sketch. But if I'm working on a self-generated project, I'll often continue to revise elements in the picture throughout the process until I'm satisfied.

Skeleton mermaid *by Mister Reusch*

Juxtaposing favourite tattoo symbols of skeleton and mermaid, this design twists these classic elements to remind its wearer of what can happen if a man falls for a mermaid – he will drown in his love and sink to the bottom of the sea.

Step 1: In pencil on sketchbook paper I drew a scary skeletal mermaid with needle teeth like a sand tiger shark's and fluorescent tentacles for hair.

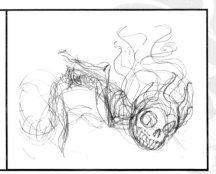

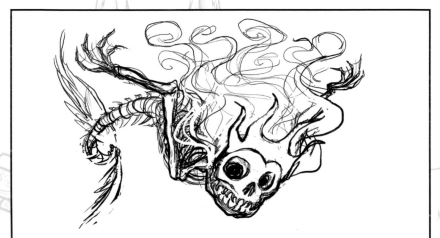

Step 2: I scanned the rough sketch into Photoshop and used the brush tool to define the linework a bit more. (You could use a brush and ink over your drawing.) I also added membranous webbing between the finger bones.

Step 3: I printed out my sketch and transferred it as line art onto 2-ply Bristol using pencil and my lightbox. Then I inked in my pencil lines using a Prismacolor premier chisel-tip marker. I used diluted Black Magic India ink to paint dark values on the skull and skeleton. Once the ink was dry, I painted the whites with undiluted white gouache to create texture.

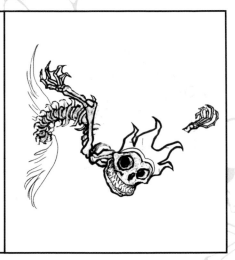

Step 4: After scanning the inked original into Photoshop, I began adding colour using a second layer in the 'multiply' mode. At this point I had planned to have glowing tentacles for the mermaid's hair, and so had outlined them in light purple.

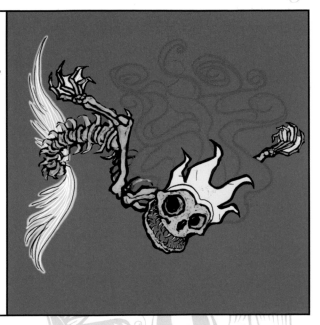

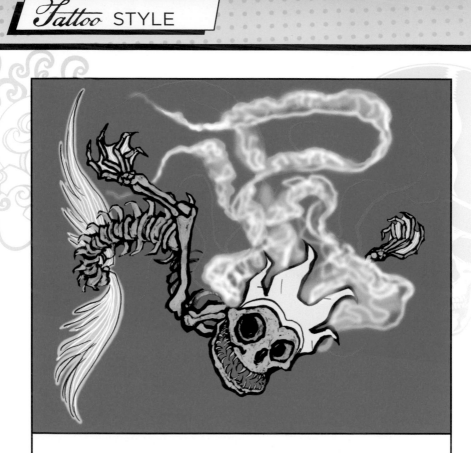

Step 5: At the last minute I was inspired by the long tentacles and transparent oral arms of the jellyfish. I therefore swapped out the tentacles, and added the jellyfish tendrils with a few different brushes in Photoshop, using soft pinks and greys.

Step 6: To make the final image, I continued to refine small details, such as the crown, jellyfish tentacles, jawbone and scapula.

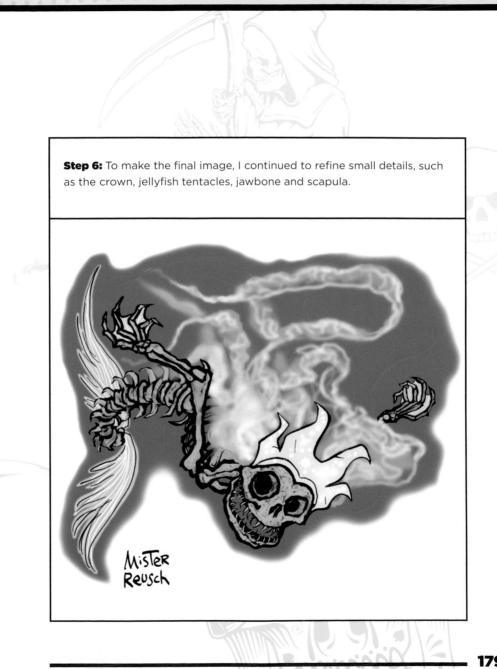

Jack o' Lantern ghost *by Mister Reusch*

Jack o' Lantern is an old skool tattoo especially popular in the United States. It has associations with Halloween as well as links with ancient Britain where it represented the end of summer and renewal as well as a time for looking back.

Step 1: Using a pencil and Prismacolor premier chisel-tip marker I sketched in a ghost figure on paper. I wanted to try to keep it simple – 1960s retro-looking and more iconic than super-detailed.

Step 2: In Photoshop, using the brush tool, I adjusted the sketch but decided it looked too much like a manta ray or something at this point.

Step 3: Using a pencil and Prismacolor premier chisel-tip marker on paper to revise the sketch, I gave the head and sheet more twists to make the ghost's rise more dramatic.

Step 4: I scanned the final art into Photoshop and began adding blocks of solid colour with the brush tool. I also got rid of the ghost's black outline.

Step 5: I then added more colour and detail to the Jack o' Lantern and started to underlight the ghost sheet.

Step 6: Finally, I created glowing eyes and an orange outline, as well as more yellow light from below.

Clown demon *by Mister Reusch*

This design draws heavily on the horror genre for inspiration. It is a good shape to sit well on the biceps and is a tattoo that might appeal to anyone with a love of all things terrifying!

Step 1: In pencil in my sketchbook, I did a very rough sketch of a demon in clown make-up and costume. At first I pictured him holding three balloons, with large curved horns and a spiky tail.

Step 2: After scanning the rough sketch into Photoshop, I made a ton of changes using the brush tool. (You could continue to refine your design on paper.) The horns were much smaller, the shape of the head was different, I added horizontal pupils like a goat's, swapped the handful of balloons for some candyfloss and added the 'invisible dog on a lead' gimmick.

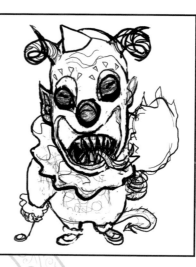

Step 3: I printed out the revised sketch and transferred it onto 2-ply Bristol with pencil and my lightbox. Using a Prismacolor premier chisel-tip marker, I continued to tighten up the linework with ink.

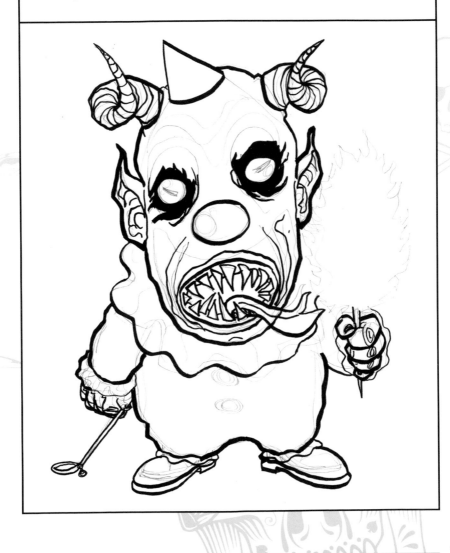

Step 4: With diluted Black Magic ink, I painted the whole face a dark value. Once the ink had dried completely, I went back in with thick white gouache to add the texture I wanted.

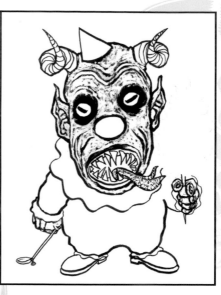

Step 5: After scanning the inked original into Photoshop, I opened a second layer in the 'multiply' mode and began adding the initial colours to the figure.

Step 6: For a final touch I used a few different Photoshop brushes to get the texture on the candyfloss and to add highlights to the clown's eyes, nose and shoes.

MISTER
Reusch

Zombie *by Mister Reusch*

This piece combines horror elements and simple composition. Reusch finds himself removing elements from his initial sketch rather than adding to it gradually. This has the result of tightening the design, making it better suited to placement on an arm rather than a larger area like the back.

Step 1: My favourite part of zombie movies is the first glimpse of the undead crawling out of the ground, so that's what I chose to depict in this first rough pencil sketch. I envisioned a windy autumn night with the cemetery ground covered in leaves.

Step 2: I revised the sketch in pencil, scanned it into Photoshop, heightened the brightness and contrast and began tightening up the image using the brush tool and some black. (You could use ink.)

Step 3: At this point I decided to do a very rough colour study in Photoshop to begin figuring out my colour choices. I wanted strong orangey highlights from a full moon and contrasting cold blues and purples on the zombie. I chose to make the leaves mostly brown so the oranges wouldn't become too confusing.

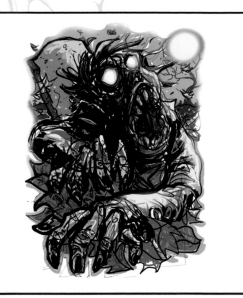

Step 4: I printed out my sketch and transferred it as line art onto 2-ply Bristol using a pencil and my lightbox.

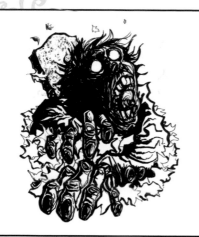

Step 5: I inked in my pencil lines using a Prismacolor premier chisel-tip marker, then used diluted Black Magic India ink to paint dark values on the gravestone. Once the ink was dry, I painted the whites in with undiluted white gouache to create texture.

Step 6: I scanned the inked original into Photoshop and begin adding my underpainting using the brush tool and a second layer in the 'multiply' mode.

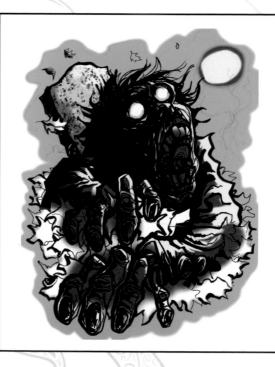

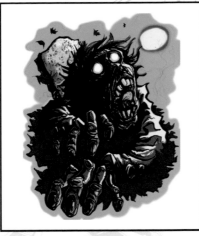

Step 7: I added blue highlights and other refinements.

Step 8: At the last minute I decided I wanted a tighter composition without showing the moon, bare tree and background headstones. These elements were too much like a traditional illustration, and I wanted to simplify the zombie for the tattoo design.

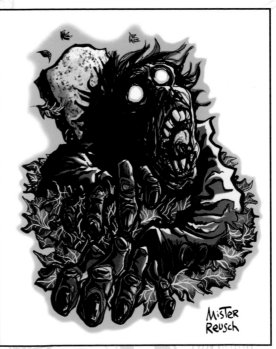

189

Chapter 7

A good design on the right part

Consider carefully the part of the body you are designing for: does it bend or crease? Is it going to move south with age? These are factors that need thinking about before you begin your design. A successful tattoo design caters for size and placement.

Getting started

Experience plays a big part in effective tattoo design, and new artists need to learn their craft and study the work of the masters. It is a long and involved process, and there are reasons why good tattoo design is not cheap. You can learn the basics here though, trying out different styles until you develop your own way of working.

Effective tattoo design

When someone approaches you to ask for a tattoo design they may have something specific in mind, or they may ask you to come up with a new design yourself. Regardless, there are several things you need to consider before moving forward with a tattoo design:

1. The skin is different colours on the various areas of the body. Obviously skin that spends less time in the sun will be naturally lighter than skin that gets a lot of sun.

2. Tanned skin does not take ink well because the capillaries are closer to the surface, which causes the skin to push the ink out.

3. There is always the option to go with black outline only – a black tattoo tends to stand out more since it reflects the greater contrast between skin and ink.

4. Size and wear and tear must be considered when selecting a design. A small tattoo on a large person can become lost; a large tattoo on a small person can be overwhelming. The aesthetics of the design need to be considered as does the way a design will interact with the part of the body on which it will be placed.

5. Where can the tattoo be placed? The answer is essentially anywhere – it's all a matter of making sure it looks good where it is. The natural contours of your body can enhance the design – rounded designs such as hearts look better on rounder parts of the body. A heart on the rounded corner of your shoulder may stand out more than on the flat area of your back.

Flash books

A client looking through flash books can't always decide what works best for the area they are considering, and as a good designer it's important to make sure they've given enough thought to the choices.

A flash book is a collection of copyrighted tattoo art mass-produced and purchased by and distributed to tattoo shops to inspire the artist and their clients. It's more than just clip-art, though. The artists who provide the art for the books still provide their own unique take on the art form. Original tattoo flash art was drawn on paper or cardboard, distributed loose and often posted up on walls in tattoo parlours.

Tattoo flash is generally hand drawn and may or may not come supplied with a line art version. The line art allows an ink artist to make a tracing to use in the placement of the design on the customer.

A great deal of modern flash on the Internet violates copyright laws as there are often tracings and retracings of an artist's work with no rights or credit given. More artists are taking action to control this practice.

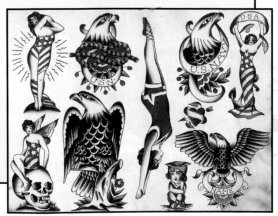

Double line tattoo design
by *Betsy Badwater*

Betsy Badwater is a full-time custom artist and tattoo apprentice to Andrew R. Trull at Black Sparrow Tattoo Studio in Pensacola, Florida. Her design for sparrow and stars contains a little tattoo joke. In the old days, Sailor Jerry Collins would often make his flash pages with backward elements to trick tattooers who didn't know how to draw. This cheeky sparrow might remind its wearer to keep his sense of humour... or its viewer that the joke is on him! This project builds on the basic bird project on page 126 so you can start there if you feel you need practise before tackling this.

Step 1: I started with a pencil sketch. Oops – the head was too small. So I grabbed a scrap of tracing paper and drew a good head over the top of the sketch and taped it down.

Step 2: I laid a second piece of tracing paper over the sketch and chose the lines I liked, using a technical pen.

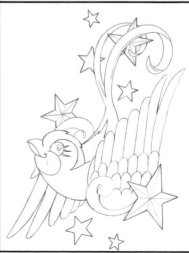

Step 3: After that I transferred the design to watercolour paper using graphite and then inked the entire outline in black.

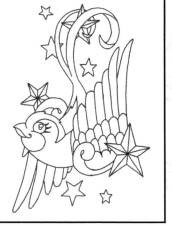

Step 4: For that old-skool 'pop', I stacked a double line around the contour of the bird only. The inner lines should remain the same value as the stars.

Step 5: Using the black ink I created the shading, keeping it simple. (It would have looked messy to add photo-realistic shading to such a super-clean design.)

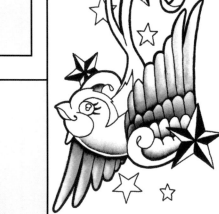

Step 6: Adding blue paint, I let it wash out very light as it moved out from the shadows.

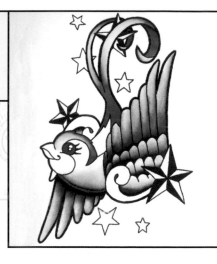

Step 7: I then filled the wings and backpatch the same solid colour, and used a darker colour for the beak. The cheeks were kept soft and blended.

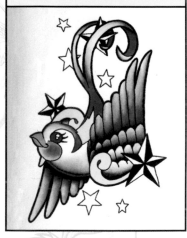

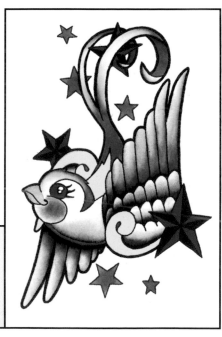

Step 8: I used solid fills on the stars. The sparrow was the focal point, so he got to wear the only white highlights in the piece.

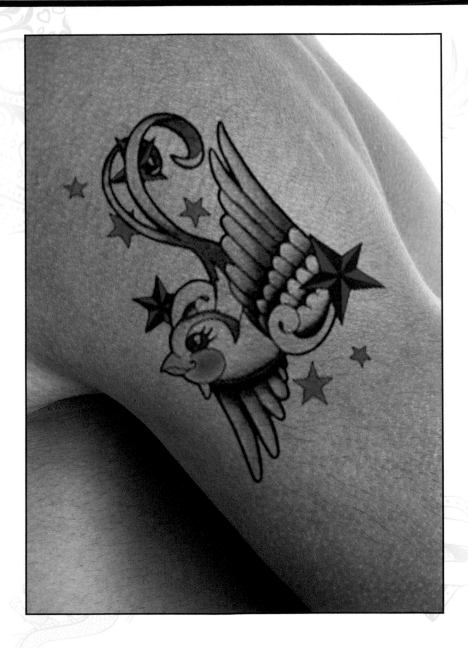

How to design for the body part

A well-known editor of a popular tattoo magazine said that on a given week he'll receive several hundred submissions to be considered for inclusion in his magazine's featured art section – and of all those hundreds of designs he also says that on a good week he finds only two or three that he would consider worthy of including in his magazine.

Choosing the right design

There is a great deal of bad tattoo art out there. Understanding the types of tattoos that work best on various body parts is the first step to ensuring that your design doesn't end up on the rejection pile.

There are other considerations too, and these will be massively influenced by the person for whom the design is intended. Among traditional cultures, tattoos tell a specific story about an individual, their character, history and beliefs. Among the Maori, a tattoo can identify someone's lineage or, for the Iban of Borneo, their status as a warrior.

In modern Western tattooing, the choice of design is a very personal one that comes down to taste. Among other reasons, people get tattooed as marks of religious devotion or bravery, as a sexual lure, a pledge of love, for protection, punishment, or to show allegiance to a group. The individual's reason for getting tattooed will also affect the design they choose. For example, a popular tattoo among prisoners is the spider's web, which symbolises a feeling of being trapped; and someone wearing a tattoo as a sexual lure is unlikely to have a large, ostentatious one. The likelihood is that they will go for something small, placed on the body in a subtle position, just about visible but easily

hidden. This is not, however, a hard and fast rule: people can delight in the incongruous and everyone is different. However, there are simple rules you can follow.

Body parts

Although there is no place on the body that can't and hasn't already been tattooed, there are some common views on the style of design when it comes to placement on the wearer.

It's important to understand that some parts of the body are not ideal locations for tattoos – the biggest mistake most people make when choosing a design is trying to get too much detail into a very small area (often creating a tattoo that looks muddy).

Tattoos on parts of the body that are designed to bend can cause a design to wear much faster than it would somewhere else. These are just a few of the things your client should keep in mind as you design their dream tattoo.

The torso can be a large canvas to experiment on, but be aware that as the body ages this area can be affected – particularly around the navel.

Biceps/upper arm

The upper arms is often the location of armband tattoos, which were especially popular in the 1990s with men and women. Pamela Anderson's barbed-wire tattoo increased the popularity of this same tattoo design for women.

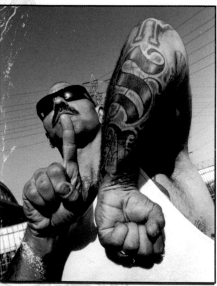

Forearms

Once the stereotype was a sailor with an anchor tattoo on his forearm (Popeye-style). Gaining popularity now, however, is the concept of the sleeve tattoo, which creates a fully rendered image from the wrist up to the elbow and sometimes continues on to the shoulder.

Wrists

Wrists are a popular body part for tattoos because they can be hidden by a bracelet or watch. They are often done in a similar style to armband tattoos.

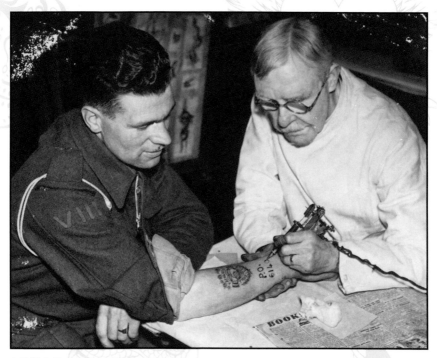

A British Royal Marine has his regimental number tattooed onto his wrist by George Burchett of London, in 1942.

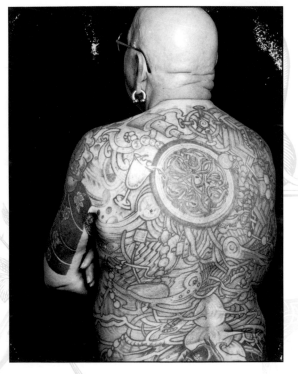

Back

It's the largest area on the body and the most like a canvas. Often people will start with a smallish design and then add to it on the back area.

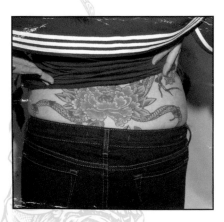

Lower back

Normally the first choice among women getting their first tattoo, the lower back is popular because it can be well hidden when in work clothes.

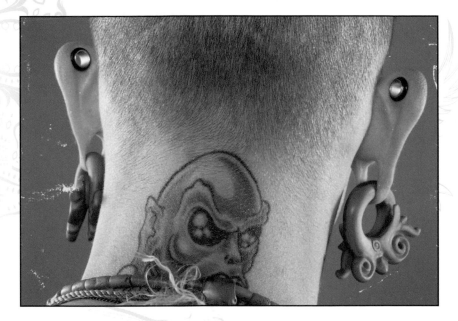

Neck

Necks were once an area many tattoo artists wouldn't touch because they are nearly impossible to hide. Even full-body circus sideshow performers would normally leave their heads and necks unmarked so that their body art could be covered by a suit of clothes should they need to attend some type of conservative function. With the growth of the punk and underground movements, however, the neck area has become increasingly popular, but the wearer should be aware of the restrictions some employers, including the armed forces, have on visible tattoos before they commit to the design.

Feet

Feet are a popular body area because they can be hidden. However, they require a lot of touching up due to the amount of wear on the foot.

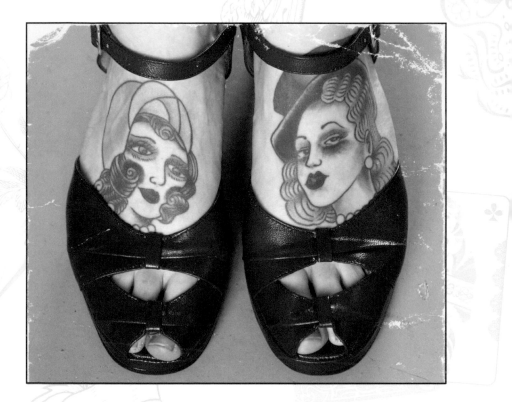

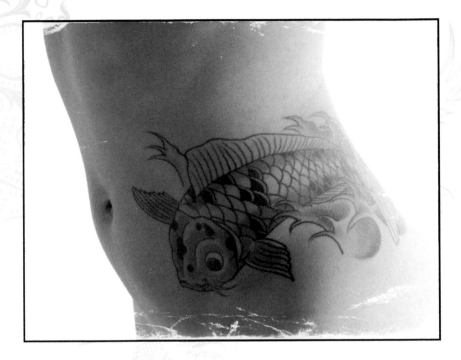

Waist

This body part is particularly popular with women looking for subtle tattoos, and is gaining ground with young men, too.

Bikini

Honourable mention goes to the bikini area – or the 'private parts'. This choice is popular and sometimes seen as sexy because of the restricted number of people who will ever see this design in person.

Sleeve linework *by Allison Bamcat*

This design has been created for use as a tattoo wrapped around an arm and features a pretty compositoin of skulls and flowers.

Step 1: I started with a rough sketch using a non-photo blue pencil, deciding on my shapes and my initial linework.

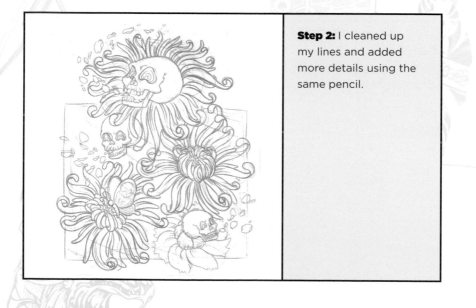

Step 2: I cleaned up my lines and added more details using the same pencil.

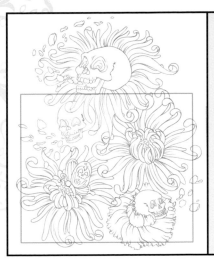

Step 3: Using a mechanical graphite pencil, I went over my lines once more. I then scanned my image and created a grey square to decide how far around the image the background should be taken.

Step 4: I printed out my image and tiled it. I taped it to a piece of 48 x 65 cm (19 x 25 in) Bristol and traced it lightly with a lightbox onto the Bristol. I worked as large as possible to make it easier to paint in small details.

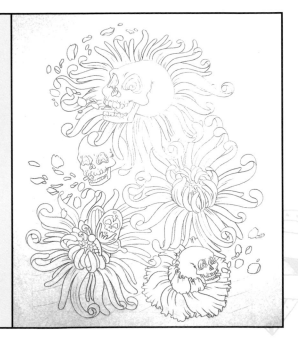

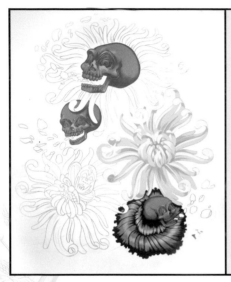

Step 5: I then began to fill in the skulls and flowers with acryla gouache. With the red flower and skulls, I worked from the darkest colour up to the lightest colour in layers, while I worked from light to dark with the green flower to keep it looking delicate.

Step 6: I filled in the rest of my shapes and did a test over part of the bottom flower to decide how I wanted my linework to look. I then started filling in the waves for the background.

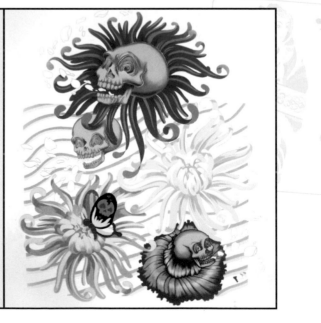

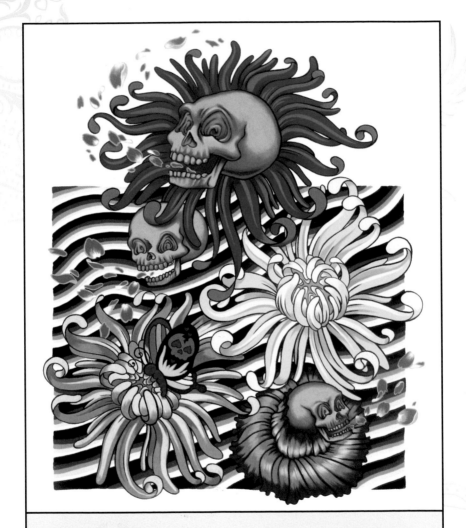

Step 7: After I had finished the background, I used black gouache to outline each element. I then painted in the petals coming from the skulls' mouths, making sure not to line them with black to keep them light and pretty.

Wrap-around tattoo design *by Edwin Ayala*

This design has been created for use as a tattoo wrapped around a limb, bringing together the classical imagery of a skull and rose.

Step 1: As always, I started this tattoo design in a sketchbook, playing around with different ideas and concepts. I drew half of the tattoo using tracing paper, to capture the rest of the symmetry. I made a rough sketch to see where I needed to take the piece as a whole. Then I moved onto the next stage, which was to make an outline.

Step 2: Once I had a sketch figured out I took tracing paper to draw out the basic linework of the sketch. I only drew out the basic lines – and none of the detail – to make the colour phase quick and easy, like any tattoo shop would. When I had the basic linework ready I transferred the linework to Photoshop to take care of the colour process.

Step 3: Once the linework was in Photoshop I lay down a basic colour set to know what I was going to be working with. From the basic colours I lay out a darker tone to give my piece more of a contrast and a rounder feel.

Step 4: After I laid down all my mid-tones I finished the piece by adding a dark shade around the whole wrap-around tattoo to give it more of my particular style. When working in a tattoo shop I may extend the vines to fit the client's arm.

The artists

The artists whose work is featured in this book are all keen illustrators with an interest in tattooing and experience of designing custom tattoos for their clients. Their work showcases a range of skills and interests, and each piece is a personal interpretation, unique in both subject and style.

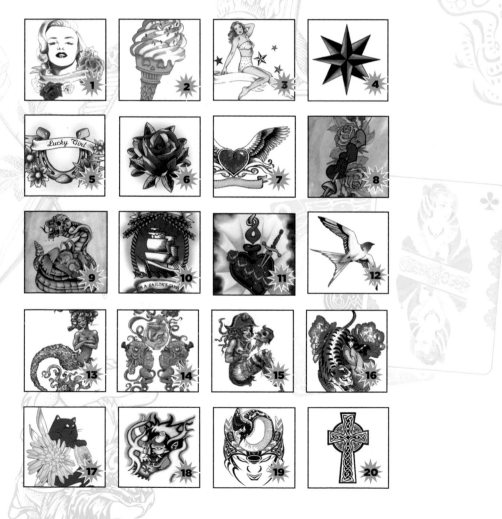

The more you know...

Tattoo designs are everywhere, and now you've read this book you're going to be noticing them non-stop. Here are a few resources that might be of interest to you and inspirational for your own tattoo-style drawing.

Tattoo flash

Remember that any flash you come across has a creator, and you need to ask the originator's permission if you are going use it for something. It is good to look at other people's designs to inspire your own, but if you want to use someone else's design directly on yourself, you will most likely need to pay for it. Most websites will allow you to buy and download their flash individually for this purpose. You must provide details of usage if you plan to use it for another purpose. The great thing about the Web is that the following flash sources are available worldwide, at any time:

www.tattoojohnny.com
www.tattooflash.info
www.bullseyetattoos.com
www.gentlemanstattooflash.co.uk
www.vanishingtattoo.com
www.tattoodles.com

Tattoo reading

There is plenty of tattoo literature to read online and every site will contain further website links. Books about tattoos and those containing designs are good because you can carry them with you as a constant source of inspiration. Here are a few of our favourites:

J. D. Crowe: *Assorted Designs* (J.D. Productions, 1996)
Lal Hardy: *The Mammoth Book of Tattoos* (Running Press, 2009)
Vince Hemingson: *Alphabets and Scripts Tattoo Design Directory: The Essential Reference for Body Art* (Chartwell, 2010); *Tattoo Design Directory: The Essential Reference for Body Art* (Chartwell, 2009)

Tattoo archives

The history of tattoos and tattooing is a fascinating subject. The Tattoo Archive (www.tattooarchive.com) has a dedicated archivist (C. W. Eldridge) who has collated many valuable resources including a research centre and information on the history of the tattoo, fascinating historical images and links to specific tattoo history on other websites.

The *Guardian Unlimited*'s 'Skin Deep' exhibition (www.guardian.co.uk/pictures/image/0,8543,-10104379957,00) is a fascinating snapshot of tattooing from various periods of history. Images are available to view online.

The Tattoo News website (www.tattoonews.co.uk) features a range of articles about developments in tattooing throughout history, as well as top tattooing facts.

Skin and Ink magazine has a useful website (www.skinink.com) with archived articles and galleries, so you can browse through past trends and keep track of the direction tattoo art is taking.

Gallery

Throughout this book finished tattoo drawings have been used to provide the reader with inspiration for their own designs as well as explaining techniques in the different tattoo drawing styles. The gallery pages that follow are the last step in getting you ready to start drawing, by providing you with inspiration for your tattoo-style drawing, whatever the style you go for.

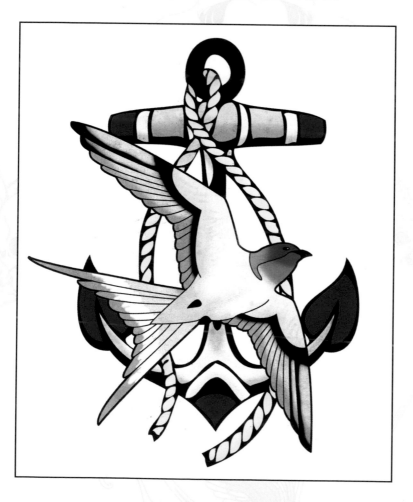

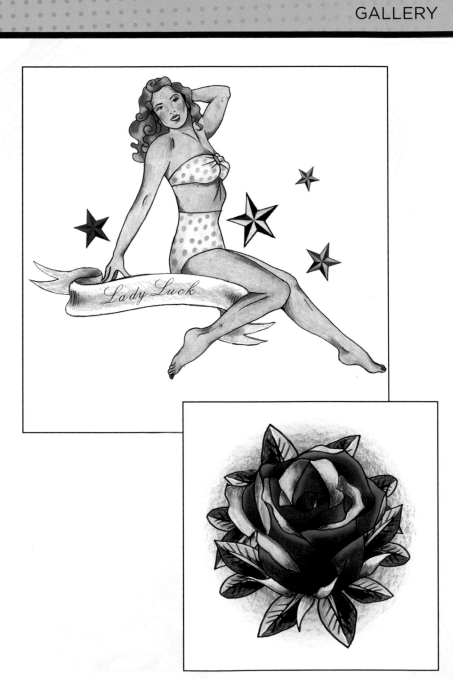

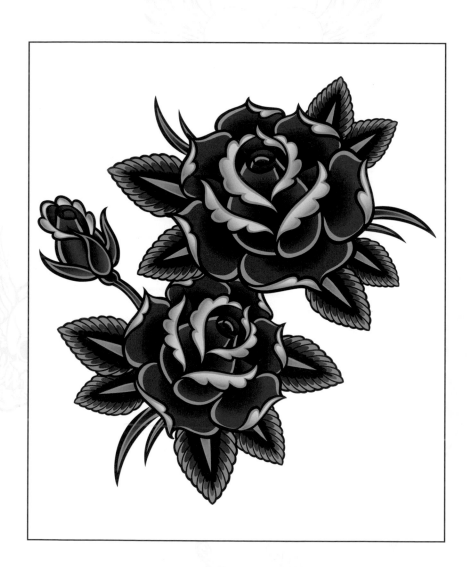

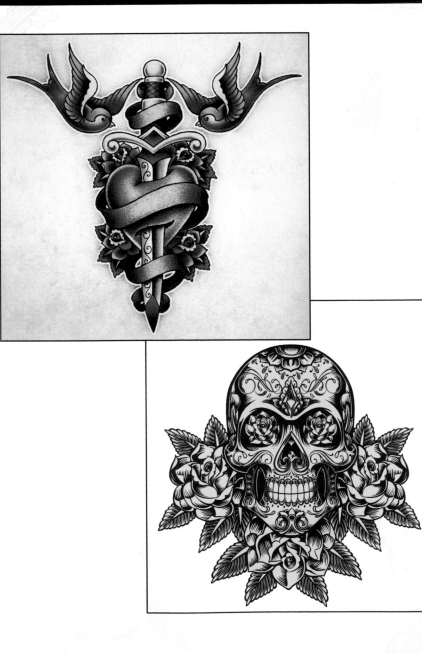

Index

Credits

All other images are the copyright of Quintet Publishing Ltd. While every effort has been made to credit contributors, Quintet Publishing would like to apologise if there have been any omissions or errors – and would be pleased to make the appropriate corrections for future editions of the book.

T = top, L = left, C = centre, B = bottom, R = right, F = far

Alamy: 96 © Sam Jones; 97B © Peter Arnold.
Corbis: 9 © Bettmann; 13 © The Mariners' Museum; 14 © Ed Kashi/ Corbis; 15 © Martial Trezzini/epa; 18 © Hulton-Deutsch Collection; 19R © George Steinmetz; 23 © Horace Bristol; 24 © Horace Bristol; 25 © Janet Jarman; 26 © Corbis; 27 © Everett Kennedy Brown/ epa; 28 © Markus Cuff; 30 © Bettmann; 31 © Bettmann; 33 © Neville Elder; 52TL © Underwood & Underwood; 87 © Hulton-Deutsch Collection; 90B © Bettmann; 91T © The Mariners' Museum; 92BL © Harry Briggs; 95 © Virunan Chiddaycha/epa; 97T © Tim Tadder; 99 © JJamArt; 100TL © Henry Diltz; 100BL © Corbis; 199 © Tony Latham; 200T © Kurt Krieger; 200B © Luca Babini; 201 © Hulton-Deutsch Collection; 202T © Marcel Steger; 202B © Mark Savage; 203 © Corbis; 204 © Toby Melville/Reuters; 205 © Larry Dale Gordon.
Derek Ring: 32.
Getty: 6 © Hemmer/NY Daily News Archive via Getty Images.
istock: 29L; 34L; 58TL; 58TR; 101BL; 142T; 143T; 143C; 144C.
Shutterstock: 19L; 34R; 38; 43L; 45TL; 45TR; 60T; 61; 86; 88TL; 88TC; 88TR; 88BL; 88BC; 88BR; 89; 90T; 91B; 92TL; 92TR; 92BR; 93; 94; 98; 100BR; 101T; 101BR; 141; 142C; 144T; 144B; 191; 218; 219T; 219B.